CITY

dustry

D1354568

AMBERLEY

I acknowledge with thanks the encouragement of Lorna Corall Dey in the preparation of the book and the contribution of the late John Mclaren in introducing me to the history of the granite trade.

First published 2018

Amberley Publishing
The Hill, Stroud
Gloucestershire, GL5 4EP

www.amberley-books.com

British Library Cataloguing in Publication Data.
A catalogue record for this book is available from the British Library.

ISBN 978 1 4456 8437 6 (print)
ISBN 978 1 4456 8438 3 (ebook)

Origination by Amberley Publishing.
Printed in Great Britain.

Contents

Introduction

It Rained Stones

Aberdeen, the Granite City; with a hinterland that abounds in granite from boulders to outcrops to mountain crags; a land where agricultural improvers gathered thousands of tons of field-stone to build mile upon mile of drystane dykes. In 1840 traveller Catherine Sinclair was so captivated by the landscape that she wrote: 'You might fancy in some parts of this country that it rained stones instead of water!'

But it was decades of labour and not rain that made Aberdeen the Granite City. The name persists despite the fact that the granite trade went into profound decline over half a century ago. For close on 200 years granite had been a defining industry of the city, a force in national and international markets. Industries come and go, often leaving evidence of their former presence. In this the granite industry is no different from other sectors of a once thriving industrial past. Where it does differ is that much of its legacy confronts Aberdonians on a daily basis. The centre of the city is granite. Grand

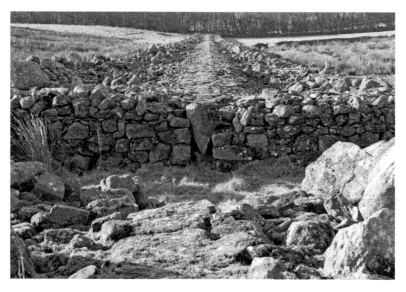

Kingswells Consumption Dyke, a bulwark of cleared field-boulders.

4

commercial, ecclesiastical and civic properties stand as witness to the trade, as do the countless dwellings to the south, the north and the west of Aberdeen's centre; all built of granite. And, as if this was not testimony enough to granite manufacture, streets paved with setts as durable as any finely cut ashlar building stone can still be found. The industry has largely gone, but Aberdeen remains the Granite City.

Please note, throughout the text I use the term Aberdeen to cover the granite industry in the city and surrounding areas. There is no intention to underplay the role of the latter; rather, this is simply a nominal convenience and to emphasise that the city became the hub for the greater part of the trade.

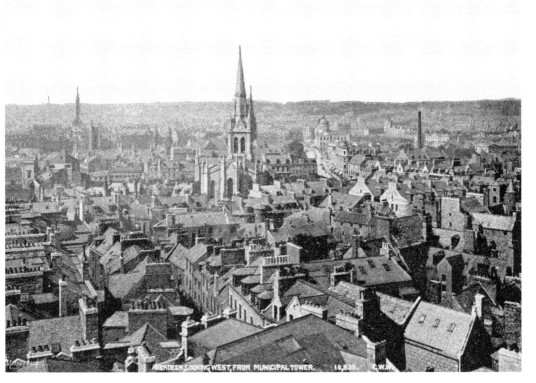

View over Aberdeen looking west, illustrating the profusion of granite buildings with the Kirk of St Nicholas's spire rising above all.

Chapter 1

Scotch Stones, Cassies and Tarmacadam

As much as Aberdeen's granite industry is famous for the thousands of memorial stones it exported around the world, and despite how it continues to be remembered in distinguished stone architecture, the creation of the industry owes a debt to a much humbler market: the need to improve urban streets. From this crucial component of eighteenth-century commercial expansion, Aberdeen found customers for its stone.

London was the key. This was a city feeling the pressures of population growth and the needs of commerce, with more pedestrians, more coaches, waggons, carts and horses all contributing to a fast-failing system of carriageway and footway paving. The search was on to find a stone able to withstand the constant battering from iron-shod horses and iron tyres. In the 1760s London's Commissioners for Roads gained parliamentary approval to raise monies to fund new paving for the city, and it was this that prompted Aberdeen stone to be shipped southward in the hope of gaining favour.

Empirical science was called on to find the best material. In 1766 experiments were carried out on three types of stone: Aberdeen 'brown granite' and two varieties of 'blue whyn'. With a combination of grindstone, weight, lever, wedge and stop watch the experimenter gave granite the thumbs-up. Satisfied, the London Commissioners 'unanimously gave their determination in favour of the Aberdeen granite, having found it to be much the harder and more durable material'.

A new and important market was born. Aberdeen 'brown granite' was laid at Temple Bar, a site more commonly associated with displaying the heads of traitors, but this Scottish connection promised a more peaceful and profitable opportunity to men from North Britain.

These early days of the industry only needed the minimum of technology. William Diack, chronicler of the granite trade, and himself a stonemason, highlighted Nigg on the south coast of Aberdeen as the original source of stone. There, 'fisher folk' supplemented meagre incomes by gathering boulders 'from rock-bound soil ... with little labour in the manufacture'.

In short order customers demanded better dressed material, such as Westminster ordering granite expected to be roughly 3 to 5 inches wide and 9 inches deep, but working to relatively big margins of error local folk fed the trade. Crudely cut the early stones might have been, but it was still estimated that with careful laying in the City of London 'there will be a saving in near 3,000 horses, and above twelve thousand pounds, annually in wear and tear, in the different sorts of carriages'.

William Diack, mason, trade unionist,
journalist and chronicler of the
granite industry.

Frenchman Pierre-Jean Grosley said London was 'the best paved and lighted city in Europe'. Not that all who saw the Scottish stone praised the imports from the North. For a brief moment in the 1760s, English national politics led to protests against all things Scottish, including granite. So incensed was one commentator that he wrote: 'I would sooner see the streets of London paved with Scotchmen's heads, than with Scotch stones.'

Granite, rather than heads, was exported, and by 1767 the *Aberdeen Journal* was reporting: 'We hear that London Bridge, and all the hills of the city, will be paved with the best assortment of Aberdeen Granites, as they are by experiment found to be the best adapted for the purpose.'

Two years later traveller Thomas Pennant witnessed a hive of activity at Torry, opposite Aberdeen on the south shore of the Dee; there, men were taking granite from what he described as 'shattery beds'. Expanding demand attracted investment and labour. Architect James Adam, brother of the more famous Robert, came to the city to exploit the new resource. James's 'Adam Style' paving lacked the splendour and opulence of his brother's contributions to London's neo-classical modernity, but it literally laid a foundation upon which both the English city and the Aberdeen industry were to secure themselves and grow.

A new industry required a new labour force. According to the Scottish press hundreds of Highlanders laboured at the quarries. These were men who spoke Gaelic, a foreign language to most Aberdonians, and to cater for their spiritual needs the Kirk established a Gaelic chapel in the city.

Eighteenth-century mason with dressing pick.

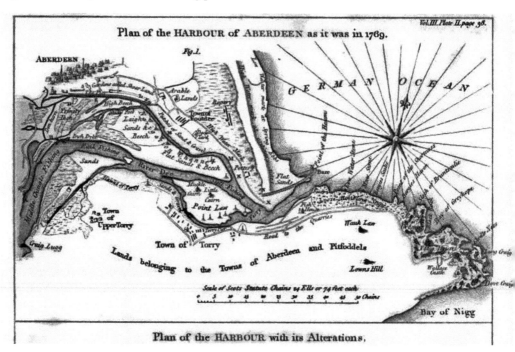

John Smeaton's plan of Aberdeen harbour in 1769, showing the road to the quarries.

The paving trade expanded through to the end of the eighteenth century. Where London led others followed and quarriers met demand by moving from semi-casual workings to more intensive operations. Firm demand for paving encouraged greater investment, including a move from coastal sites to better workings inland. The early sites at Torry and Nigg had the advantage of close proximity to sailing vessels, but as the trade established itself and profits and roads allowed, quarriers were able to move farther from the harbour. By the last decade of the century landowners were leasing properties with the inducement of granite quarries on their land. One site became particularly associated with paving manufacture – Dancing Cairn at Auchmull, 3 miles from the harbour, which meant quite a haul for carts laden with stone. Unsurprisingly, transporting stone on what were weak rural roads caused a great deal of damage, enough for the Aberdeenshire roads trustees to threaten quarriers with legal action if they persisted in causing 'great injury' to the Inverury turnpike. The Dancing Cairn (which became plural with development) was said to have been so productive that by the mid-1790s its owner could claim it was the site 'from which the London market is chiefly supplied with pavement'. To the north was Cairngall by Peterhead, which was a considerable distance from Aberdeen; however, like others that were developed in Buchan, this quarry had pretty direct access to shipping, so its distance from the growing commercial centre of the Scottish granite trade had little relevance. What was important was the quality of the stone and the ability to extract, dress and transport it with as few add-on costs as possible.

As the paving industry grew, the skills necessary to work the hard stone increased. When James Anderson was surveying agriculture in Aberdeenshire in the 1790s, he gave a detailed description of how the stone was cut. Quarrymen, he said, worked granite with 'surprising adroitness', with the men detecting natural cleavage planes in what to the untutored eye looked like a granular mass lacking distinct splitting structure. Witnessing the men at work and enquiring as to the skill of cutting, Anderson was told there was a grain to follow. However, 'should they attempt to split the stone in any other direction than that of its natural greet, as they call it, they never would succeed.'

Cutting paving for London improved skills and created better streets, which in turn encouraged ever more traffic carrying heavier loads; eventually, even carriageways paved with the best Aberdeen granite began to suffer. The stone was as hard as ever. The problem was engineering; foundations were weak and the shape of paving was wrong.

Generally the street paving exported from Aberdeen followed the pattern of blocks cut in the form of a wedge, tapering to the base. This was easier, quicker and cheaper than cutting more cuboid paving. In 1819 roads engineer James Walker, who oversaw the laying of Aberdeen paving at the heavily used East India Dock in London, said that stone must be 'properly squared and shaped, not as wedges, but nearly as rectangular prisms'.

This point was echoed the following decade by Francis Maceroni, who in contrast to the opinion of Grosley fifty years earlier thought that the carriageways of London 'were worse than that of any other metropolis in Europe'. A champion of Maceroni's views went so far as to claim the streets of Britain, including those paved in Aberdeen stone, were barely passable: 'The causeways are rugged, rutty and merciless to the flesh and bone.'

It was back to the drawing board. When William Knight, Professor of Natural Philosophy at Marischal College, visited quarries in the 1830s he found men producing a range of standard setts: the Common Six, the Cube, the Sovereign and Half-Sovereign.

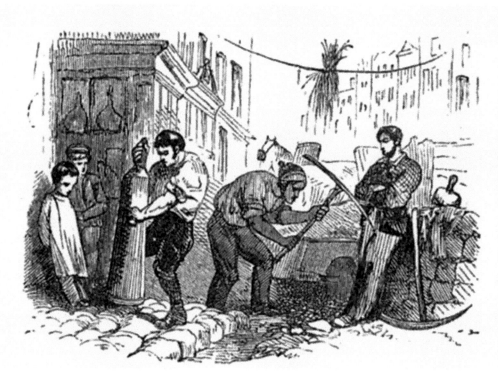

Eighteenth-century paviors.

Quarriers briefly offered a muckle sett called the Imperial with nominal dimensions of 12 x 9 x 12 inches deep. It was not a success, however, as it was too large and a sore trial to paviors. The most popular stones for London were the Sovereigns (10 x 8 x 8) and Half-Sovereigns (10 x 6 x 7).

Stability improved with the move away from the old fashioned wedge-shaped paving, only to highlight the question of which dimensions were best suited to the trot of horses' hooves and the run of iron-tyred wheels. Durability was not in question; what mattered was how safely horses could move across the new improved roads and could carriage and waggon wheels handle the more rigid jointing. Once again the London engineer James Walker came forward to demonstrate that by reducing the breadth of a paving stone, greater safety was obtained. He showed that when cut to the large dimensions even the best Aberdeen granite was, nonetheless, hazardous to horses. Fatal falls were far from uncommon, which, apart from the tragedy for the poor horse, endangered coach passengers and pedestrians and was liable to bring commercial activity to a halt. Walker's answer was to cut stone according to the size of the horseshoe. From 1835 to 1840 Walker supervised the reconstruction of Blackfriars Bridge, including re-laying the carriageway. He found that paving of 3 inches in width was best suited. Over the next fifty years, as new roads were opened and old ones re-laid, reduced paving was introduced across British cities – so much so that by 1899, when William Maxwell published a treatise on the construction of roads, setts were often no more than 3.75 inches to 4 inches wide.

The large stones that William Knight had seen being cut were no longer required, the old names were redundant and the terms granite sett and cube tended to be used. In Aberdeen 'cassie' (drawn from the term causeway) became ubiquitous. Just as frequently, however, and with a hint of the ghost of an even older form of road-making, streets would be described as cobbled. Illustrating how far the manufacture of stone paving had progressed from large wedges in the eighteenth century, leading British municipal engineer H. Percy Boulnois was insistent that settmakers should be instructed to cut within one quarter of an inch of the specified dimensions – a long way from the boulders of the fisher folk of Nigg.

Through the nineteenth century the quarries of north-east Scotland not only extracted stone for building and monumental purposes, but were hives of activity filling orders for cassies, guttering and kerbing, all designed to speed the movement of people and commodities. Hundreds of settmakers worked at the quarry sites, sheltering beneath relatively portable open-fronted wooden huts known as scathies, which they were able to turn according to the direction of the wind and driving rain. At one side there was undressed stone to be worked and opposite a growing mountain of finished setts waiting for distribution to local markets or to be shipped from Aberdeen to customers in the south. Settmakers negotiated prices for stone; piece work dominated their working lives. When customers demanded more exacting standards, men struggled to make

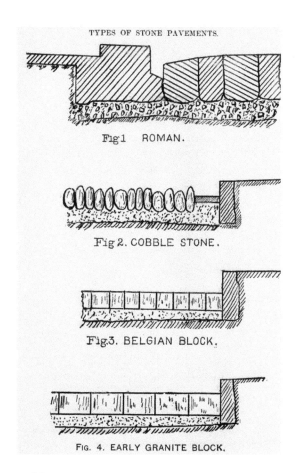

Types of paving.

11

jobs pay, forcing them to renegotiate prices or attempt to hide poorly cut stone. In the 1920s the elderly quarryman John Ritchie looked back on the days of mid-Victorian settmaking. He recalled men sending cartloads of paving to Aberdeen harbour, to be quality controlled at the quayside by one Johnnie Barclay, who was apparently a stickler for good granite. Settmakers contrived to beat the overseer's sharp eye by encouraging carters to hide poorly cut paving at the bottom of a load; otherwise, the man was liable to be called to the quayside to put matters right, without additional payment.

Carters tend to be a forgotten part of the granite labour force but without them there would have been no viable trade. In the 1860s, according to John Ritchie, there were as many as forty carters working out of Slattie quarry at Bucksburn, north of Aberdeen city centre. These men, 'clad mostly in white moleskin trousers and sleeved waistcoat, he said, looked sometimes a rough lot ... a bit uncouth [but] as a rule their first consideration was their horses'.

The roads to and from quarries were said to be thronged with traffic. No doubt, apart from any humanitarian concerns, the carters' dependency upon the horses for their livelihoods would have welcomed the introduction of improved narrow granite setts.

It was all very well for the granite trade to have given a firm foundation to London's traffic, but what of Aberdeen's own streets? Were they kept up to the mark? Until the second half of the nineteenth century, the answer was generally no. Granite was fine for other cities but was usually a bit beyond the pocket of local ratepayers. However, when a prestigious new street from the Castlegate to the harbour was being laid, commissioners specified: 'Granite such as was wanted for the London market, 7, 8, or 9 inches in the crown or superior part of the stone.'

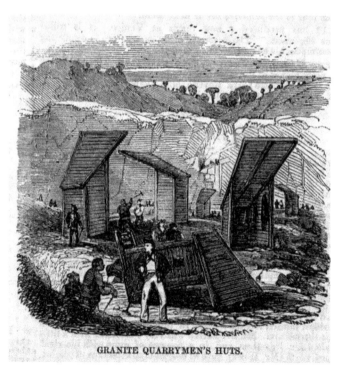

GRANITE QUARRYMEN'S HUTS.

Nineteenth-century Rubislaw with quarriers' scathies.

This was exceptional. As a visitor of 1801 remarked, 'a sort of flint and pebbles' rammed one way or another to give a running surface was more typical. As late as the 1830s the important Broad Street was described as being 'wretchedly paved'; the undemocratic councils of the time had to walk the political tightrope of keeping traffic moving without antagonising the relatively small numbers of ratepayers by asking them to pay for the more expensive, albeit locally manufactured, granite, what one writer called 'our Aberdeen Diamonds'. But needs must. If commerce was not to be brought to a halt, then squared stone had to be laid. In 1846 2,000 tons of squared granite were needed for Union Street; old stone was lifted, re-dressed and laid elsewhere in the city. As late as 1869 the great granite manufacturer Macdonald & Field despaired of the state of the road at their granite yard's main gate, complaining that Constitution Street 'was in a wretched state'. At Virginia Street by the harbour things were no better. Granite might be prolific across the North East, but here by the docks it was definitely in short supply. Aberdeen's town engineer complained to the council that 'the pebbles with which the street is now laid had been shifted and turned so often, that would shift or turn no longer'.

Just short of the twentieth century, in 1894 one 'Rosemounter' went so far as to say the carriageways and footways of the area were often 'quagmires ... a network of swamps'. As it happened this part of the town was close-by one of the earliest sources of local granite, Loanhead quarries. Improvements did come with squared granite cassies becoming the norm, encouraged by the passing of the Municipality Act of 1871.

Granite expertly cut and properly laid seemed unchallengeable or so the local industry thought. But in the 1840s a competitor did emerge in the form of wood paving. Its great advantage was that it was quieter than stone. In 1838 London's Oxford Street was partially laid in wood; a year later the same had been put down outside the Central Criminal Court, all the better it was thought to deaden street noise and raise the majesty of the Law. In the following decade it became a mania as investors caught the scent of dividends. Even Aberdeen was not immune. Residents in the city's Adelphi offered to lay wood at their own cost. The notion was derided by one Aberdonian: 'As long as the Dancing Cairn lasts, they need not try wood pavements.'

Wood paving, however, found a politically important local advocate in Provost Thomas Blaikie, who, having seen it used in London in 1843, said he thought 'the Wood Pavement which [he] saw there a great improvement, and [he] was told it stood admirably'.

Fellow councillor Alex Matthew was aghast. He thought 'the Board ought to be the last to go into this expensive Paving'. The granite was a principal trade in Aberdeen and if they introduced wooden pavements into their streets they could expect to have little trade in granite. He had 'occasion to be in London last summer', and he saw that the 'horses could with difficulty go on the Wooden Pavement without coming down'.

Provost Blaikie won the day and as an experiment wooden blocks were laid on St Nicholas Street. But over the rest of the decade it became clear that wood was not a serious challenge to stone. Apart from the claim that sodden wood gave off unhealthy vapours, it was found that for all the assertions made by manufacturers, and despite the variety of shapes available, the useful life of wooden cubes was significantly less than granite. The settmakers of the Dancing Cairns, Slattie and elsewhere could rest easy, or rather could continue to work hard.

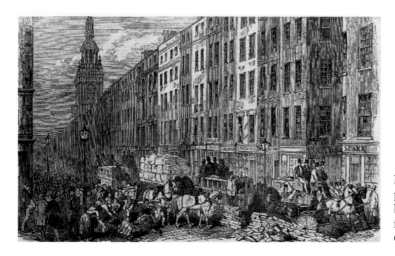

Deficient wood
pavement
being removed
from London's
Cheapside, 1846.

Through the rest of the nineteenth century thousands of tons of cassies and kerbing were sent from quarries, but like so many other trades its nemesis was not far away. Granite setts were labour intensive. After the foundation was prepared, each block of granite was bedded by hand, followed by ramming and grouting. Skilled paviors were needed. Attempts had been made to mechanise sett manufacture, but production remained a craft of manual skills. However, it was another inherent problem which increasingly set many against cassies, a problem necessarily coincident with the vast increase of horse-drawn traffic: noise. The poet James Thomson caught the urban cacophony when he wrote that city streets were places of 'booming and the jar of ponderous wheels, the trampling and clash of heavy ironshod feet ... The rolling thunder seems to fill the sky'.

When Aberdeen's trams were electrified from the 1890s local journalist and mason William Diack nostalgically told readers that he regretted that 'the steady jog of the tramway cob was becoming a thing of the past'. What he did not say was that this particular four-legged friend was one among thousands. As early as the 1870s one physician had pointed to the clatter of the streets as injurious to health, sufficient, he said, 'to shorten life'. Just as other cities were finding the noise of iron on granite intolerable, so too in Aberdeen, and this is mentioned as early as the 1840s when a school teacher complained of the 'noise occasioned by porters' hurlies and other vehicles', all distracting pupils. In 1903 the Burgh Surveyor reported that Union Street was plagued by the volume of sound: '[An] intolerable noise hurtful alike to health and property ... one had the greatest difficulty in speaking to a friend in audible tones.'

Back came Shoremaster Boddie. Defending granite setts, he 'wanted more noise, as noise was a sign of business and prosperity. It was an exhilarating noise ... the music of the horse's hoofs made one feel inclined to mount his own hobby horse'. William Boddie was one of the city's foremost granite masters, so this might well have been special pleading.

Footway paving had seen a move away from granite and other stone flags with the introduction of cement, a material opposed by the stone trade. Eventually, however, it was more or less accepted. A local product that was in a sense a half-way house was

Adamant Stone, an artificial product made from 'useless rubbish' of crushed granite waste, bonded in a matrix of Portland cement. This was hard wearing and could be manufactured in a range of sizes. Made from the 1880s at Dancing Cairns by A. & F. Manuelle & Co., it soon found a ready market across the country, but it was no substitute for highway paving. Regardless of the fact that Adamant brought business to the stone trade in 1905, unemployed masons canvassed Aberdeen Town Council with the argument that only true granite paving should be used on footways. The council was not deterred. At one moment in the following year, Councillor Taggart, who owned a granite memorial business, came out against the use of Adamant, but not to favour pure granite, instead promoting concrete.

In the end, tarmacadam proved to be the nemesis of granite. With training and experience, the semi-liquid mass could provide a stable and relatively smooth surface that was much quieter to travel on and was capable of being laid at a faster rate than the individual setting of stone. Coincidentally, the end of the nineteenth century, when tarmac was spreading across city streets, also saw the emergence of motor transport and the introduction of rubber tyres, which must have seemed like silent running to the ringing ears of the time.

In 1895 a deputation of Aberdeen councillors visited towns in England to gauge the success of tarmac. They were enthused by its 'noiselessness, freedom from dust and mud, and ease of traction'. Recognising that the introduction of tarmac was a threat to the north-eastern economy, the local press denounced the deputation. Granite, it said, 'is an important industry, and one not lightly to be slighted by the Aberdeen Town Council'. Councillors were castigated for having 'macadamised minds'. Settmakers rallied to

1890s wood paving still challenging granite.

defend their trade and through the United Trades Council sent a deputation, insisting the council 'ought to try and nourish a local industry' and have nothing to do with the 'dark, dingy, dirty look' of tarmac. When it came to a vote the tarrie brigade won insofar as it was deemed suitable for secondary roads. Like an alien bacillus, once introduced it began to spread, and despite running battles through the 1890s and into the twentieth century tarmac gradually killed off setts as the paving of first choice. There was a long, slow death to the sett industry. As it became necessary to repair cassied streets, the opportunity would be taken to lay tarmac, and where a new street was to be opened the black stuff took precedence. A sign of the changing fortunes of granite was the opening of Aberdeen's prestigious beach Esplanade in 1922. No longer taking the side of settmaking, the press wrote: 'With smooth broad carriageway and pavement, laid all the way with tar-macadam, the esplanade will provide an enjoyable carriage and motor drive, or a pleasant afternoon or evening walk for pedestrians.'

By 1935 William Diack was commenting on the sad state of settmaking, with some 30,000 tons of unwanted cassies lying in local quarries.

Post 1945, with the reconstruction and modernisation of ageing infrastructure, the rate of removal of granite paving increased and in Aberdeen this was accompanied by a demand to take trams from the streets. The city took the decision that trams had to go, which meant lifting setts to remove rails; the perfect opportunity to have tarmac laid. In 1951 Great Western Road was given the treatment but rather than simply removing close on half a million cassies, the engineer decided to lift them, re-lay them in a bed of concrete and then – and this must have caused great heartache to settmakers – a coat of tarmac was spread across the granite. The aesthetic of the street changed, noise was reduced and literally and symbolically the settmaking industry was buried. Seven years later the coup de grâce was given when Union Street, the pride of the city, saw a similar fate.

As surely as the settmaking industry was being killed off, it was not the end of granite and road making. Broken stone was used in tarmac, and stone-breaking machinery and coating plants began to be seen in local quarries. Much like the 'rubbish' for Adamant, paving debris – 'pinnans', which had previously been waste, and of little economic value – could now be a money-making venture. John Fyfe of Kemnay Quarries, in his usual innovative way, set a marker for the industry when he invested considerable capital to exploit a new market; namely railways, as they began to replace permanent way sand and gravel ballast with broken granite. The granite master brought in two Baxter stone crushers, which, between them, were capable of manufacturing 1,000 tons of ballast per week. A new network of rails was laid at Kemnay to carry stone to the crushers and graders, with the primary product going for railway use and the finer residue being sold to line private drives and walks. Like the processes of manufacturing tarmacadam and Adamant paving, this innovation at Kemnay altered the pattern of skills of the quarrying industry. Crushing stone was machine-centred labour. The ability of a man to read the 'greet' of granite was not required.

Technological and market forces coalesced to consign settmaking to the pantheon of largely lost trades. The physical durability of Aberdeen's premier stone was never in question – witness how old cassies can still be found paving city streets – but no matter how great its strength and its seeming indestructibility, the granite could not resist the forces of competition.

Aberdeen cassies at Theatre Lane.

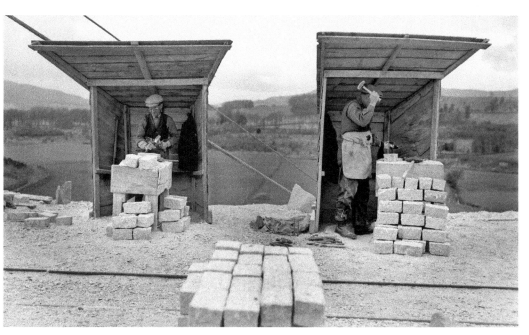

Settmakers at Kemnay quarries, 1939. (This image was digitized with grant-in-aid from SCRAN, the Scottish Cultural Resources Access Network. Reproduced with permission of British Geological Survey. Permit number CP18/008)

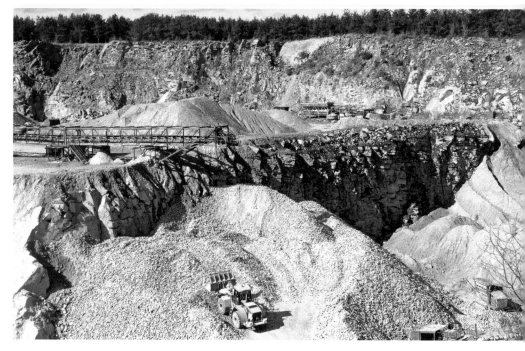

Craigenlow Quarry, showing large-scale aggregate production by Breedon in 2016.

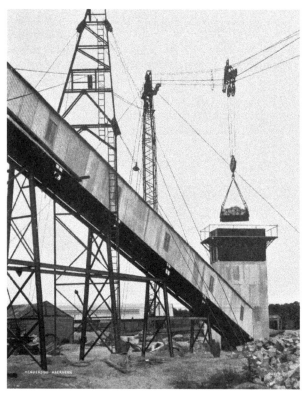

The crushing plant at Rubislaw.

Chapter 2

There Winna be a Stone Wintit Oot o' Yer Quarry

From the 1760s through to the twentieth century, the pattern of quarry development in the North East was typified by the necessity of relatively easy transport links from quarry to working site. Moving heavy stone was costly and in winter was virtually impossible. Initially two focal points emerged, with Aberdeen as one centre and Peterhead to the north as the other. With its harbour Aberdeen was the export point for London and other markets. Peterhead was over 30 miles from Aberdeen, which meant that there was no way that the potentially abundant supplies of granite could be carried overland to the city, but it did have a harbour, giving it a gateway to distant customers.

As roads improved, making inland transport that much easier, quarries could then be further from the harbour. For four decades this was supplemented by the opening of a canal from Aberdeen to Port Elphinstone on Donside. From 1805 until its demise in 1849 the canal carried stone to the city, and in addition its locks and embankments were built of granite. The canal was not a great economic triumph, however; profit was hard to come by and eventually shareholders sold out to the Great North of Scotland Railway. Aberdeen was linked to the national rail network southward in 1850 and over the following fifteen years branches extended west out towards Deeside and north towards Huntly and Donside. Granite areas that had hitherto been exploited only locally now became economically viable. The line to Alford on Donside and another to Aboyne on Deeside were completed in 1859 and granite quarries exporting stone to the city opened along the lines of the new transport. Driven by John Fyfe the most important quarry in the history of the industry burgeoned on the Alford railway at Kemnay.

However, as early as the first decades of the eighteenth century, James Elmslie had 'dug into the bowels of the earth' at Loanhead, the grey granite being used in the building of Robert Gordon's Hospital (1839) and, it would seem, the original infirmary at Woolmanhill. Steady exploitation attracted labour and by the 1780s Loanhead was said by Francis Douglas to be a 'considerable village'. An advert of 1805 promised would-be quarriers that its granite was 'inexhaustible', made doubly attractive by the fact that the road to the city was toll-free. Mason-builder Patrick Scott leased land, using the stone for local housing as well as gravestones, and even small hand-polished granite work. He employed cutters and blacksmiths, trained apprentices and had a stone yard down at the harbour.

Beyond the city limits, to the north-west, were the quarries at Auchmull – Dancing Cairn, where in the 1780s George Laing and Robert Smith extracted stone. When the land was rouped in the 1790s the agent promoted it not only on the basis of the beauty

of the Donside estate, but also on the basis that its quarries presented any would-be purchaser with the opportunity to acquire a business with a history of providing valuable stone to local and national customers. Not far from Auchmull were quarries at Clinterty, Hilton and Cairncry, all supplying stone for local needs, including road metal, which was important when it came to the building of the Aberdeen–Inverurie turnpike.

On the outskirts of Aberdeen was Rubislaw Quarry. When it finished its working life in the 1970s the quarry was over 400 feet deep, which shows how wrong Aberdeen's councillors were in the 1740s when they accepted the opinion that the site was poor in granite and that what was available for the proposed new West Kirk would in any case be too expensive to dress; hence why James Gibb's freestone West Kirk was built, albeit with a granite foundation course. As poor as Rubislaw was thought to be, it was nonetheless quarried, although the men were unaware of the riches that lay hidden deep beneath the overburden, known locally as barr. Told that 'the stone is of poor quality and of no use for building', the town council sold the land to Skene of Rubislaw in 1788.

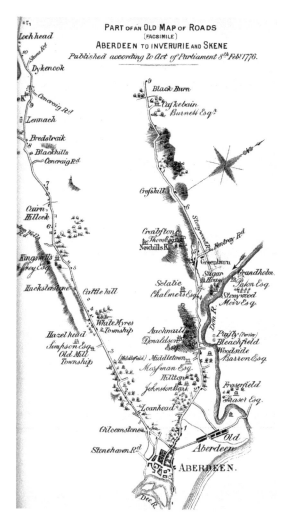

Plan of 1776 with Loanhead, Auchmull and Sclattie sites prominent.

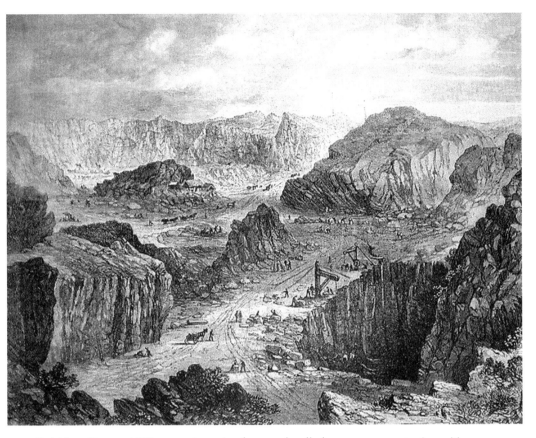

Rubislaw Quarry, 1850s; prominent is what was locally known as an oxter (armpit) crane.

Like so many of the North East's quarries, Rubislaw could only be systematically worked when the barr was removed, exposing the beginnings of a 'post' of good stone. This presupposed a willingness to invest in the expectation of finding a market for granite. Step up John Gibb and later his son Alexander, both civil engineers. Recommended by Thomas Telford, in 1809 Gibb the elder was appointed to oversee improvements to Aberdeen's harbour. With extension to the North Pier and a breakwater opposite, Gibb sourced granite from quarries around Aberdeen and, in the words of Telford, 'with unremitting attention superintended every operation'. Roughly dressed granite and better quality ashlar encased a core of rubble gneiss, which, because of its intractability, was known locally as 'heathen' stone. Granite blocks from 3 to 6 feet long weighing 5 to 30 tons went into the improvements. This was the background to John Gibb taking a lease of quarries at Rubislaw and from there Gibb & Son oversaw the development of a business that became famous across the world. William Knight's survey of 1835 describes Rubislaw as having 'a gigantic aspect', far surpassing the site as worked by previous tenants. Not every quarrying enterprise by John Gibb was successful, however. For seven years he leased the quarry at Tyrebagger, but eventually abandoned the work as the cost of carting stone to Aberdeen was too high; 'a very losing concern', wrote Dr Knight.

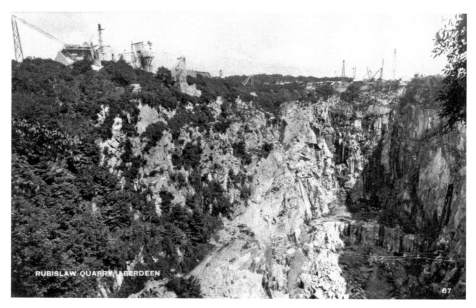

Twentieth-century Rubislaw, with crane jibs and Blondin masts.

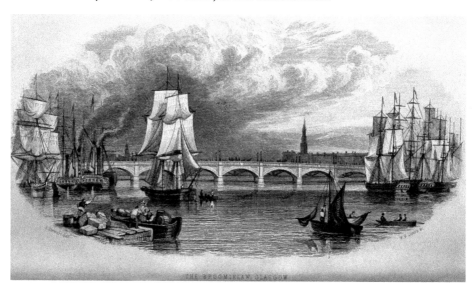

Broomielaw Bridge, Glasgow, built by John Gibb & Son, 1830s.

The Tyrebagger was only 7 miles from the harbour at Aberdeen but distant enough to forestall development. On the other hand, Peterhead, about 40 miles to the north, had no such problem. There granite was abundant, with harbour facilities close at hand. Clustered to the south by Boddam were quarries at Stirling Hill, Black Hill and Longhaven; and to the west of Peterhead there was the inland site of Cairngall. While grey and blue stone was found in great quantity in the Buchan area, it was red granite that made it famous, which

was particularly desirable in a polished form. With the advantage of harbour facilities Buchan quarries were extensively developed. Large blocks for civil engineering, for ornate columns and for smaller memorials as well as the seemingly ever-present mountains of granite setts were conveyed to Peterhead for onward shipment. It was estimated that as early as 1793 the modest quarries around the fishing town annually exported 1,000 tons of paving to London. Waste stone was dumped into the North Sea.

It's very telling that when John Rennie was designing and supervising the building of Southwark Bridge in London, rather than selecting suitable stone in Aberdeen it was the northern quarries that met his needs. In 1814 Rennie's son had been sent to Aberdeen in search of good quality granite in blocks of 15 to 20 tons, but the would-be Granite City disappointed him, its quarries being 'merely adapted for getting paving stone'. More to the point, Aberdeen quarry masters were uncertain about being able to supply the quantity required, and anyway, as the young Rennie said, the price was too high. So it was he looked north to 'where the red granite abounds' and found a more sympathetic reception and stone. Rennie Junior supervised quarrying a stone some 10 feet long by 5 feet square, the quarrymen being 'rewarded with ample wages and a good supply of whisky'. The journey to Peterhead 4 miles distant required a specially strengthened waggon and quayside lifting gear designed by the young engineer. This was quarrying on a grand scale. In the engineer's words, stone could be had 'at the least possible cost ... [and] yield a fare profit for the capital expended'.

New companies arrived to lease sites, such as Macdonald & Leslie of Aberdeen, who in the early 1840s experimented with polishing stone from Cairngall, and in the 1850s began leasing the quarry, using the stone for their own customers rather than general trading.

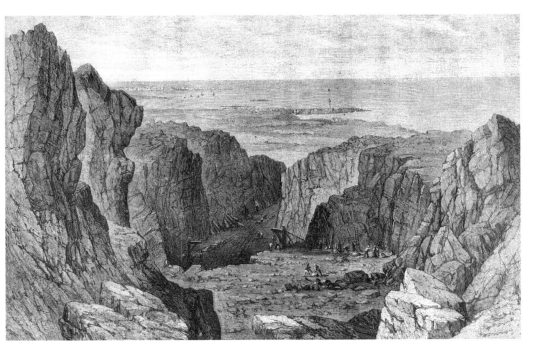

Peterhead Quarry, 1862.

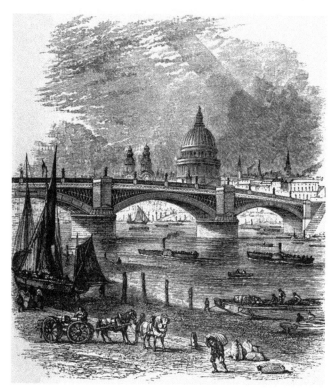

Southwark Bridge.

In the 1860s John M'Glashan of Invernettie leased the quarry at Boddam, supplying his polishing works with stone. Heslop, Wilson & Co. took on the adjacent site to the north in 1871. Then, in the search for a decorative blue-grey granite twenty years later, Heslop, Wilson & Co. leased Rora Quarry with the expectation of a thriving trade, only to be disappointed. Despite installing cranes, employing twenty quarriers, removing a great deal of barr and finding good-quality stone, they were hit by the costs of carrying stone by road to the nearest railhead. By 1899 the quarry floor was described as covered in potentially fine building stone, but because of high transport costs it was effectively rubbish.

A sign of what might happen to a previously productive quarry capable of filling the demands of both local and national markets was the fate of Cairngall, which until 1883 had been worked by Macdonald & Co. In the words of one-time manager Robert Fergusson, it was 'left to stand idle, for the reason that the old quarry was worked done'.

Cairngall dropped out of the larger market place. It was reopened in 1887 by John Cruickshank, who started in the granite business about 1870 as a donkey engine boy for Macdonald & Leslie, was then apprenticed as a settmaker and later spent eighteen years in America. On returning to Peterhead he resumed his acquaintance with Cairngall, but unlike his earlier days the quarry now largely satisfied local demand for building stone, setts and rubble, with a small amount of stone for polishing still being found.

At Rora Heslop, Wilson & Co. had been thwarted by the lack of a close railway connection. In contrast was the birth and growth of the quarries at Kemnay on Donside. Like so many sites granite had been intermittently quarried to meet local demands, but

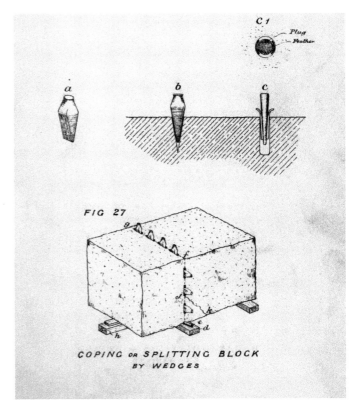

The plug and feather method of splitting stone.

Tapping plugs at Rubislaw quarry. (Image part of a collection donated by Mr Hugh O'Neill. Reproduced with permission of British Geological Survey. Permit number CP18/008)

until the building of the railway north and west from Aberdeen it was too difficult and expensive for would-be entrepreneurs to exploit, no matter how good the stone. The coming of the railway changed all that; so much so that from its industrial beginnings in 1858 Kemnay grew to be bigger than quarries of Buchan and went on to surpass the businesses of Aberdeen.

John Fyfe was the man behind the enterprise. Prior to opening of the Alford Valley Railway in 1859, Fyfe had been operating a quarry at Tyrebagger, supplying stone to the railway company. Advised by builder Adam Mitchell that Paradise Hill, Kemnay, had great potential, the young quarrier leased the land and began clearing the overburden. Like most of the Aberdeenshire quarries the early excavations had men cutting straight into the hillside, which made the extraction of stone straightforward – sufficient for small volumes of stone, but increasing the depth of the quarry was the only way of finding a large mass of high-quality granite. It did, however, pose the problem of moving stone from ever deeper quarries. At Gibb's Rubislaw this was resolved for a time by carts following a steep spiral track rising from the quarry floor, which only delayed the problem of 'the getting, the getting up and the getting off' of granite from great depth.

At Kemnay Fyfe was alive to this difficulty of raising stone from the floor to the quarry bank, for by 1865, with one hole now about 70 feet deep, he had co-operated with engineer Andrew Barclay of Kilmarnock in designing steam derrick cranes. Seven years after entering Kemnay he had five cranes on site as well as steam pumps

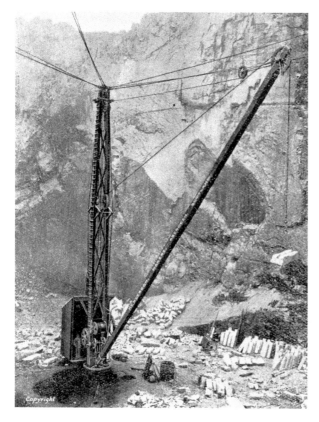

'All round' crane by Henderson of Aberdeen. A similar crane was installed at Rubislaw in 1897.

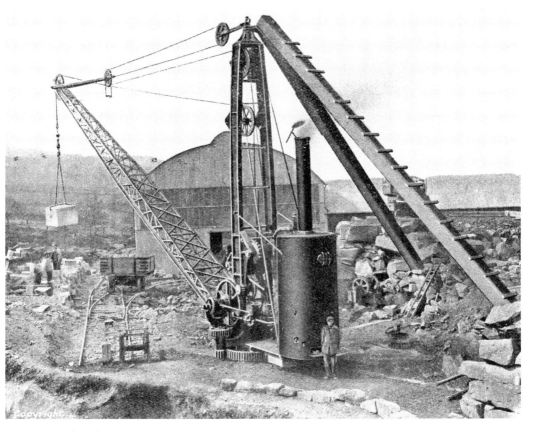

Steam derrick crane.

to deal with the inherent problem of water accumulating. Expenditure on advanced technology was only possible because of the quarry's direct connection to the Alford–Aberdeen railway. With a system of railways in the quarries, including a winding engine to haul loaded waggons, stone was taken directly to the branch line. And illustrating how Fyfe sought to integrate technology across his enterprise, 'fanners' pumped air to the essential blacksmith's forge. So impressed was a visiting American stonecutter in 1894 that he said it was 'a remarkable circumstance that not a single horse is employed'. He must surely have missed one small detail, which the local paper enthused about in 1896: 'Amidst the noise of steam engines, steam pumps, steam cranes, steam drills, and the clatter of stone crushers, it is a relief to see waggons being shunted along the siding by the primitive agency of a work-ox.'

Early in the 1870s John Fyfe went one step further. Seeing a ropeway that delivered mail across the River Dee at Abergeldie Castle he came up with the notion that a similar machine might lift stone. As a result, the Blondin was born. This was essentially a crane that straddled a hole and was capable of lifting stone from the quarry floor to the bank. Combined with fixed derrick cranes this made raising good stone and clearing 'pinnans' from working areas simpler and more economical. Demand for these new technologies

Abergeldie Castle in 1864. The ropeway, seen to the lower left, is said to have inspired John Fyfe's Blondin.

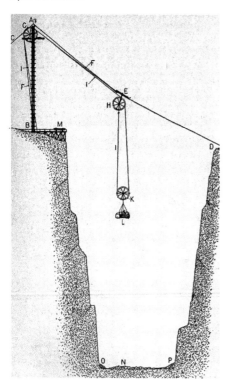

Method of taking stone from the quarry floor at Kemnay in the nineteenth century.

was satisfied by Aberdeen's engineering firms, such as William McKinnon, but it was John M. Henderson that established a worldwide reputation for the manufacture of cranes and cableways. Needless to say, capital investment at this level implied expectation of profitable quarrying.

From Kemnay, John Fyfe filled contracts for paving, civil engineering and building, as well as supplying stone to Aberdeen's monumental yards. The white-grey stone was exceptional in its lightness of colour and was sought after for prestigious building projects such as Aberdeen's Town House and the modern Marischal College. When Fyfe first leased the quarry he was told by a local he was wasting his time: 'There winna be a stone wintit oot o' yer quarry for the next nineteen years.' How wrong. The coming of the railway and opening of the granite quarry brought Kemnay into an industrial economy and by 1865 200 men were employed by Fyfe.

Further west on the Alford line quarries opened at Tillyfourie and Corrennie, and close to the Bridge of Alford there was Syllavethy. The former two were the most important, with direct connections to the railway line. Tillyfourie, worked by Mowlem & Co. until the 1890s, was best known for the quality of its setts and kerbing. The dark blue stone had a balance of durability and capacity to wear sufficient to keep a surface rough

Quarrymen splitting stone after a blast at Kemnay Quarry, 1939. (Image part of a collection donated by Mr Hugh O'Neill. Reproduced with permission of British Geological Survey. Permit number CP18/008)

enough to give traction. When Mowlem gave up the lease from Sir Archibald Grant in 1891 the quarry lay idle until the later 1890s, when John Fyfe decided to turn the abandoned waste to his advantage: some settmaking re-started, crushers were installed and road metal was hauled from the site.

Directly to the south, Corrennie, also quarried by Fyfe, became famous for its pink granite, which was of a softer hue and more finely grained than the better-known red Peterhead. Corrennie grew to be larger than Tillyfourie and survives to the present day, albeit mostly for aggregate production. Corrennie expanded in a more open form, making access and hauling of stone that much easier.

Quarries came and went with building cycles and demand for paving. When the national demand for setts rocketed in the late 1890s, it was said that as many as sixteen new and previously closed sites were brought into production, but they could just as quickly close. On Deeside, for example, Sundayswells by Torphins was opened about 1900. Described as supplying a stone that took a good polish and was eminently suitable for monumental work, this was not enough to save it, and by 1914 merchant Henry Hutcheon reported that it had all but closed. Hutcheon's own Hill O' Fare Quarry, producing a fine red stone, was no longer in production and there was little prospect, he said, of it re-opening.

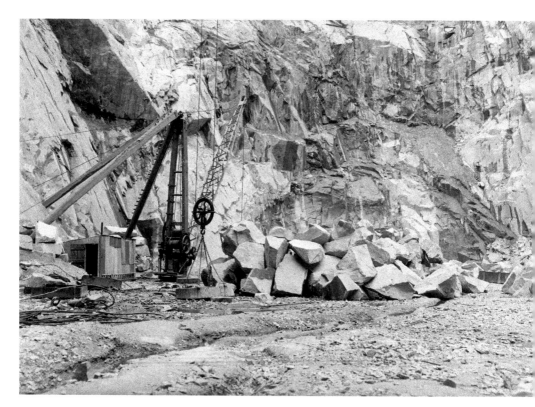

Quarry floor at Sclattie with a Blondin skip and crane. (Image part of a collection donated by Mr Hugh O'Neill. Reproduced with permission of British Geological Survey. Permit number CP18/008)

Chapter 3

Sublime Classicism, Ruinous Dwellings and Lofty Tenements

With the birth of the paving industry, Aberdeen's stone merchants had followed the money. By the end of the eighteenth century thousands of tons of stones had been exported, but regardless of how many more were to be sent south it is unlikely that Aberdeen would have gained the title the Granite City without itself adopting dressed granite as a building material. Granite had to be seen rising above the humble stone cassie or alternatively incorporated in bold examples of civil engineering.

Aberdeen granite played its own part in building the infrastructure that defended and promoted the interests of fast expanding British commerce. Dockyards, harbour works, lighthouse construction and bridge building were major projects for which engineers demanded Aberdeen granite. When in the 1790s Sir Samuel Bentham was tasked with improving naval facilities at Portsmouth, he chose expensive Purbeck stone and Aberdeen granite. Similarly, the dockyard at Sheerness employed the city's stone, although there were complaints made as to its expense.

What was first choice for the dockyards was also used at Aberdeen; various schemes were undertaken, with Smeaton, Rennie and Telford advising. The focus of attention was the North Pier and a south breakwater. Under instruction from Telford, John Gibb completed the pier foundation 'entirely of granite' in 1809, and two years later the breakwater was built 'composed of roughly dressed granite ashlar and headers from three to six feet long', with stone coming from quarries all within 4 miles of the harbour. Blocks from 5 to 30 tons were taken to the pier head: 'A very arduous task,' said Gibb, 'accomplished without accident.' French engineer Charles Dupin marvelled at the work, commenting: 'Immense operations have begun to render Aberdeen a great commercial port; superb piers have been constructed at its entrance.'

Earlier, in the heart of the city contractor William Ross supervised building of Union Bridge. With a single span of 130 feet, all in dressed granite, a classic piece of engineering with masons using the traditional hand pick to dress stone, Union Bridge was the ideal exemplar for the durability, utility and grace of granite. Just as civil engineers had eagerly sought granite for harbour works they also ensured that the stone was used in their bridges. Both senior and junior John Rennies were responsible for incorporating Aberdeen and Peterhead stone into London Bridge in the 1820s. The 4-ton foundation

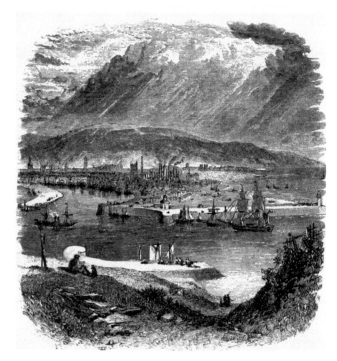

Aberdeen harbour
entrance with Gibb
harbour improvements.

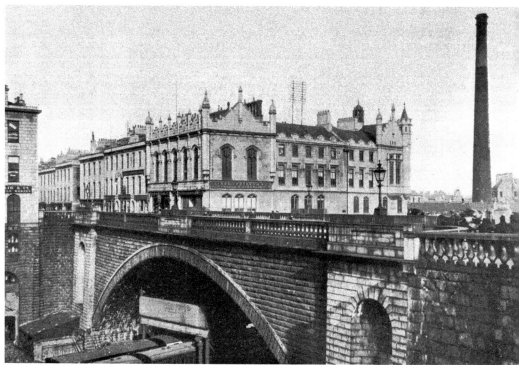

Aberdeen Union Bridge, prior to the widening of the north face. At the south-east abutment is John Smith's Trades Hall, a Tudor style departure from neo-classicism.

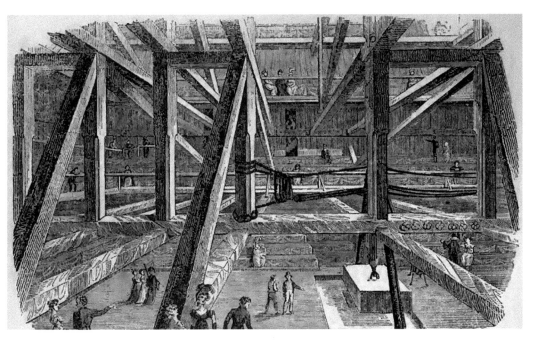

Laying the granite foundation stone at London Bridge, 1825.

stone of Aberdeen granite was laid to great ceremony in 1825, the whole enterprise described as extolling all that was best about the country: 'British Empire flourishing in glory, wealth, population and domestic union.'

But as glorious as London Bridge was for sheer spectacle, it could not match what was achieved at the Bell Rock Lighthouse, where Robert Stevenson employed masons from Aberdeen 'accustomed to the use of the boring iron and pick, in working granite'. Recognising how dangerous and isolated the work offshore was, ten of the men negotiated with Stevenson, asking for '20 shillings per week, summer and winter, wet and dry, with free quarters ashore, and likewise [their] victuals when [they were] at the rock. As for Sunday's work and premiums, [they would] leave that to the honour of [their] employers'.

Onshore, apart from sandstone coming from Mylnefield, granite from Rubislaw quarry was shipped to Arbroath, where it was dressed. Stevenson acknowledged sandstone would have been cheaper but argued that the 'little additional expense' should not stand in the way of ensuring a solid face to take the battering of the sea. Aberdeen's quarry struggled to supply sufficient stone and eventually Stevenson had accept that granite would be incorporated in only the first 30 feet of the lighthouse's outward casing. There was no problem about the quality of the stone supplied but Stevenson found that Rubislaw, being normally concerned with the supply of stone for 'common house purposes', was ill-prepared for handling such a volume of large pieces and as a consequence a quarry was opened at Cairngall to help meet the shortfall. The Bell Rock light beamed out in early 1811.

Half a century earlier Aberdeen's merchant class had taken up the challenge of building a city fit for the 'improving' eighteenth century, the first signs of which can be dated to the gradual development of Marischal Street, linking the Castlegate at the heart

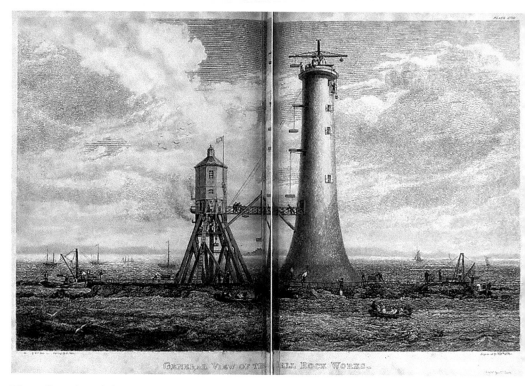

The Bell Rock Lighthouse.

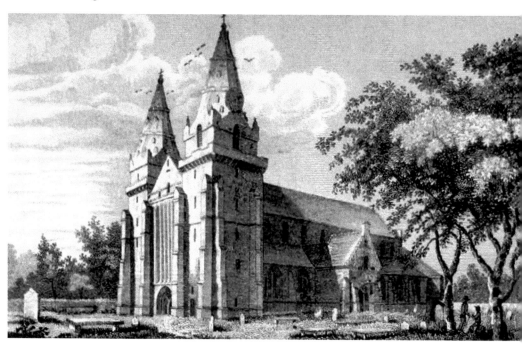

St Machar's Cathedral, Aberdeen's medieval statement in granite.

of the city to the quayside. In one sense the new carriageway was an expression of an old style of commerce and industry insofar as the dwellings with shops erected along the street line were to accommodate wealthy tenants within the hustle-and-bustle of city life, cheek-by-jowl with the lives and work of the poorer classes.

Sitting high above the harbour, Aberdeen's Castlegate had the advantage of providing the civic heart of the town with an open prospect, which meant the route from the Castlegate to the quayside involved a steep fall southwards, requiring a bridge about two thirds of the way down. This was a major piece of civil engineering which must have become a model and inspiration for the much bigger and defining project of bridging the haugh at the Denburn. In both instances granite was the stone chosen, or rather as the contract for Marischal Street called it in 1767, 'hill-stone'. With great pomp and ceremony the foundation stone was laid in March of 1768. The Master of St Machar Lodge of Freemasons told the assembled dignitaries that this was 'a work of no small importance', a claim echoed almost 250 years later by historians David Walker and Matthew Woodworth, who described the project as 'seminally important ... a pioneering example of a flyover, it is of European significance'.

Builder-architects such as William Law and William Dauney feued ground and over the last decades of the eighteenth century, using granite from Loanhead and Rubislaw quarries, erected elegant Georgian houses, demonstrating that the skills of the freestone mason could be transferred to the harder obdurate stone. When Francis Douglas surveyed the North East of Scotland in the 1780s he wrote: 'A fine new street has been lately made ... a very handsome street the town was at very considerable expense in raising it to a gentle slope.' Douglas also made passing reference to the then better class of housing elsewhere in the city, noting, 'The houses in general are built of granite cut in squares and smoothed, some of them better than others.' Most of these would have been rubble-built with some dressed stone at quoins and lintels. The fine housing going up on Marischal Street was that step up the ladder of quality and fashion.

By the turn of the eighteenth century local masons and builders had accumulated the skills necessary to dress granite profitably. Given a customer with enough money the way was open for a bold architectural gesture to demonstrate the full aesthetic and engineering potentials of granite. This arrived with the new century, when architect James Burn of Haddington received a commission from the Aberdeen Banking Company. Standing at the north end of Marischal Street, adjacent to the commercial and civic heart of the city, the resulting building was a bold statement in granite. Taking a classical form, with pilasters, recessed and arched windows and frieze, it was an example of what the local stone industry might do. When finished the largely ashlar-dressed bank must have been a revelation to all who saw it; or, as historian William Brogden put it, was 'on the edges of architectural decency'. Having massive solidity, and clean and uncluttered lines it contrasted not only with the fine domestic architecture appearing on the new street, but also the weathered softness and ageing of the Town House and Tolbooth, which stood to the immediate north. *The Aberdeen Censor* of 1825 described the scene: 'Sombre freestone has been gradually superseded by the blazing granite.'

The volume of granite required was immense, and to ensure it followed the demands of the classical aesthetic consistency of colour was necessary. All cutting was by hand, the main tools being the axe and the pick. As skilled as the masons proved to be, James Burn's project did hit a momentary snag when the final flourish of a balustrade

Gordon's Hospital (College), Aberdeen.

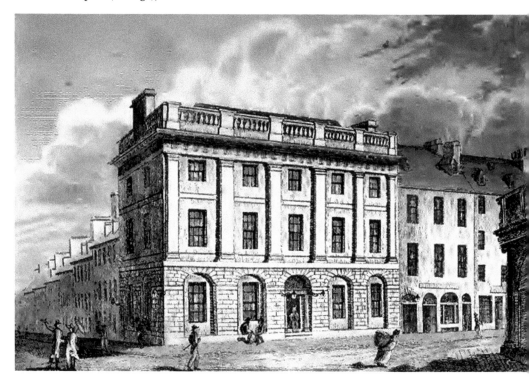

Aberdeen Bank, at the head of Marischal Street.

atop the building was incorporated. With the balusters having to be cut on the round, this required more intricate and time consuming work. In September 1801 the contractor advertised for 'seventy granite balusters, agreeable to a pattern, to be seen at the New Building in the Castlestreet [sic]'.

The architect found the number of balusters required could not be readily provided, so a temporary measure of having them cut in sandstone and painted to match the greyness of the granite was resorted to. But as William Knight reported, by 1804 the skills and speed of cutting by hand had improved sufficiently to ensure there were no such problem cutting balustrade for Union Bridge, and so the 'large and handsome edifice', as antiquarian Joseph Robertson described the finished bank, was completed.

Among those impressed by the beauty of the bank was Monymusk-born but London-based artist Andrew Robertson. In 1816 he entered a competition to design a suitably heroic monument to celebrate the victory at Waterloo. Andrew's entry was bold: 'I shall only want one or two hundred Aberdeen masons, for it must be Aberdeen granite ... There is no part of the building requires better work than is on our Aberdeen Bank, in short, the chief part of the work would be done in Aberdeen.' He called for no less than fifty-six Doric columns 35 feet high. Sadly for Robertson and Aberdeen's stone industry, the granite Parthenon of Primrose Hill did not get beyond the drawing board.

Come the new century, new men – local men – took up the challenge to show what marvels could be achieved with Aberdeen's stone. Finding clients with sufficiently deep pockets, architects John Smith and Archibald Simpson transformed the city's landscape. John Smith's father, William, was himself a builder; a tradesman who worked on the new houses at Marischal Street. His stonework was said to have been of the highest quality – good enough for the historian David Miller to state that William had 'a formidable reputation as the best builder in granite ashlar'. Archibald Simpson was less fortunate: his father was a clothier rather than a builder, but he did have a strong connection to the granite trade through his uncle, William Dauney, who was responsible for fashionable architecture of Marischal Street.

If Marischal Street was the sparkling granite gem of late eighteenth-century Aberdeen, then for John Smith, Archibald Simpson and their contemporaries Union Street was the jewel to promote the grandeur of local stone. Running from the heart of Aberdeen westward, the eastern stretch, including the construction of Union Bridge, was a massive civil engineering project, which entailed the purchase of properties, demolition, raising levels and building granite vaults. It was anticipated the high capital costs of this venture would be recouped by letting land along the line of the street. In the event the rate at which properties were eventually feued was insufficient to cover the debt carried by the town.

Grand visions of a new street with terraced housing and stylish villas never came to pass. Development was fragmentary and failed to emulate the more impressive architecture of Edinburgh's New Town. But slowly the two architects put their stamp on the street. In 1807 John Smith was commissioned by Patrick Milne to design a house west of Union Bridge. No matter that the house displayed the fine use of local granite, Union Street Trustees were far from happy, believing that it intruded on their expansive vision of 'symmetry and regularity'. Standing in what was then a semi-rural situation, the house presented itself as both a sign of the wealth of Patrick Milne and the merit of granite as a material capable of satisfying the demands of discriminating

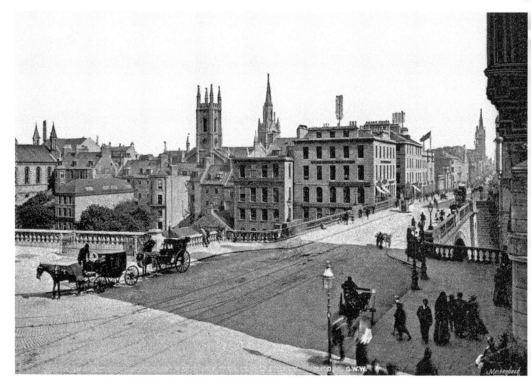

Looking east across Union Bridge.

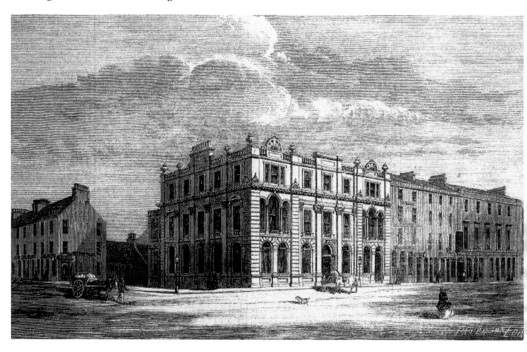

James Matthew's Town & County Bank, 1860s.

private patrons. In its architectural severity it met the aesthetic demands of the period. Granite's refusal to be easily carved not only limited what the stonecutter might do, but also restrained the imagination of the architect. George Robertson's survey of 1810 pointedly said: 'From the extreme hardness of this stone, we should hardly expect it to be applicable to any purpose that required shape, far less a polish. But we have only to witness the elegant mansions that have lately been erected in Aberdeen, of this obdurate material, to be convinced that it is a species of stone very much adapted to building, and susceptible of ornamental embellishment.'

As we shall see the notion that granite could not be polished proved to be wrong. In a more combative style, William Knight praised the limits imposed by the stone as it meant that 'much bad taste in every freak of architectural deformity is avoided'. In other words, at a time when classical solidity, simplicity and durability was fashionable, Aberdeen's stone trade was able to supply the best of building materials.

Back at the city centre Smith took up the task of turning plans drawn up by James Burn into an elegant terrace extending from Castle Street northward on King Street. But just as Union Street was developed piecemeal so the King Street project became a fragmented development. Nonetheless, John Smith's continuing use of dressed granite gave the city centre a sense of what might have been.

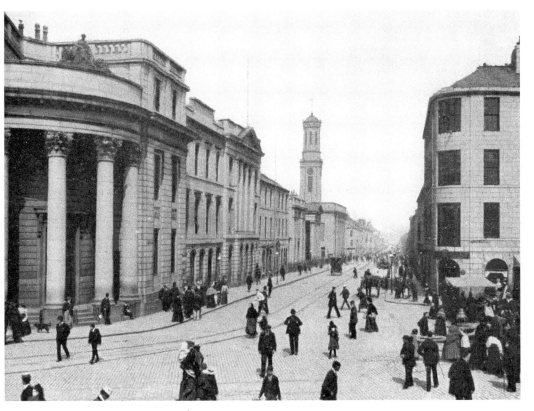

Looking north from Castle Street up King Street, with John Smith's architecture to the right and Simpson's to the left.

A later starter, Smith's colleague and competitor Archibald Simpson made his earliest foray on to the would-be Union Street in 1813 when, in the words of David Miller, the 'severe and sober' Union Chambers was built. This was followed shortly after with the 'cubic mass' of the Aberdeen Hotel at the north abutment of Union Bridge. A year later, in 1818, Simpson was working on a building for the Medico-Chirurgical Society, another neo-classical addition to the city, boasting a portico with four large ionic columns, flanked by Doric pilasters. Completed by 1820 and close to Smith's works at the south end of King Street, the new medical hall went a small way towards realising the grand architectural vision of an elegant and fashionable road north out of the city.

Over the next twenty years Simpson made his mark on the urban landscape, providing Aberdeen with a sense of the architectural glories of antiquity. Having earlier made his mark on Union Street he became the architect of choice for the prestigious Assembly Rooms (now known as the Music Hall) west of Union Bridge. With six monolithic Ionic columns and a grand porch, the Assembly Rooms gave civic dignity to the street and was most certainly a signal to the burghers of Aberdeen that wealth and the good things of polite society were accumulating in their native city. At the laying of the Rooms' foundation stone Freemason and Grand Master the Earl of Fife praised Aberdeen for making 'gems from the barren rock'. He told the assembled dignitaries that although the rooms were not intended for use by poorer classes, all in the city should be proud of what was being achieved with granite, especially as Aberdeen had not 'been obliged to resort to foreign artists to finish the design of the Public Rooms'.

Assembly Rooms (now the Music Hall) and Union Street, showing well-laid setts.

Immediately north of the Assembly Rooms Simpson designed a new infirmary to accommodate poorer classes, and this was another classically inspired structure. Those unfortunates fortunate enough to be recommended for treatment at the hospital (well-off classes were treated at home) found themselves in a civic building where pilasters and plasters awaited patients: the infirmary's classical architecture boosted the self-image of philanthropy and as far as possible physicians and nurses cured the afflicted.

Returning to Union Street, another creation of Simpson was one which marked the city's entry into the era of modern retail – the covered, arcaded Market. With its colonnaded main hall over 300 feet long, the Market was vast, inspiring the editor of the *Aberdeen Journal* to inform readers that the hall was like 'the nave of a great cathedral'. Given the subsequent worship of mass commodity production, this was an apt description. The building provided covered accommodation for many dealers who previously sold their wares in the open air. Not content with giving Britain its largest modern granite 'cathedral', Aberdeen Market Company raised the profile of the local stone industry even higher by erecting within the hall an imposing granite fountain. With two upper cups, the largest 7 feet in diameter, and an even bigger reservoir beneath, this piece of decorative art in polished red granite – 'smooth and glossy as glass' – was the epitome of what could be achieved in Aberdeen's and Peterhead's stone.

Apart from the direct monetary costs of construction and the purchase of land, there were enormous human costs to this enterprise as old granite buildings were cleared and Market Street was laid out, making tenants homeless. It was all very well for the local press to describe the cleared dwellings as 'ruinous' and the area as 'the abode of poverty, and the haunts of disease', but as desperate as conditions were they did provide some shelter to the poor. Neither the town council nor Simpson and his fellow developers

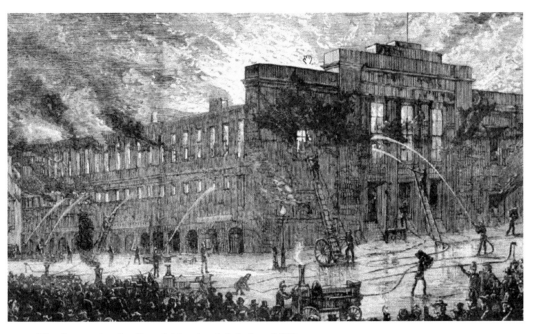

The destruction by fire of Aberdeen's Market, 1882.

made any provision for new housing – not that the architect was averse to providing dwellings, but only at a price way beyond the means of the homeless. In the 1820s he made his most important contribution to Aberdeen's housing stock when he designed the streets and dwellings about Bon-Accord Square and Crescent, the latter described as, 'sublime ... the finest neoclassical street building in Aberdeen'.

Set in what was then a semi-rural situation south-west of Union Bridge, the Crescent was only for the wealthiest of Aberdonians; there was no room there for those spilling from the rookeries of the old town.

City 'Improvement', as it was called, gathered pace right through the nineteenth century, almost always creating opportunities for the granite industry. Smith and Simpson peppered the city with fine town houses as well as civic and commercial buildings, not to mention the demand generated post 1843 when the Established Kirk split in two.

As much as the architects and their clients were taken by the neo-classicism and the heightened restraint imposed by the hardness of granite, not all observers were overawed by the beauty of the emergent Granite City. Indeed, the very success of granite as a building material became a source of complaint. Buildings might be admired individually, but when seen en masse, it was said, the clarity of line and re-imagining of classical form suffered because of the very limited colour palette of Aberdeen's blue-grey stone.

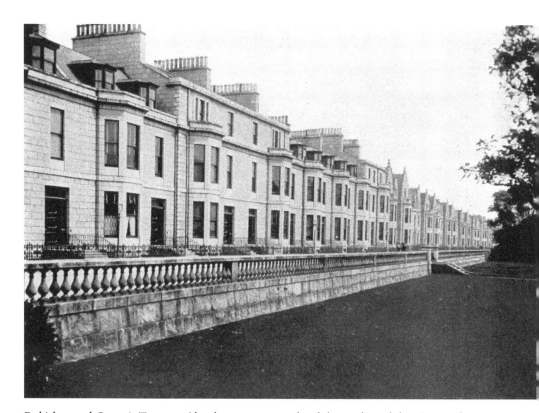

Rubislaw and Queen's Terraces, Aberdeen – an example of the quality of the nineteenth-century granite housing available to those with wealth.

Broad Street, hinting at the poorer quality of Aberdeen's housing.

Blaikie & Sons' metal works,
Littlejohn Street.

By the 1840s Aberdeen's landscape had been sufficiently transformed for the town to be referred to as the Granite City. High colour was no part of the architectural wonder. Hues and textures could be had by varying cutting techniques; for example, ashlar could be set against rustication to give contrast. As Billings wrote in the 1840s, careful examination was required to appreciate granite. By the 1860s the prodigious output and appearance of greyish stone was, for some, becoming a visual burden. Englishman Charles Richard Weld was unimpressed by Union Street, the pride of Aberdeen. He expected the street to be dressed in the red granite of Peterhead and was disappointed when confronted by 'dull grey granite [which] is by no means pleasant to look upon'. Weld was more impressed by the technology in the granite works of Macdonald & Leslie. Five years later the prestigious *The Builder* took up the aesthetic issue and although the writer saw the stone as 'glittering white', nevertheless he found it trying on the eye. Even the sun could not raise the warmth of the stone. Quite the opposite; granite, he said, had a 'cold and chilling influence on the mind'. Looking northward over Union bridge provided 'positive relief' in the shape of Simpson's brick-faced spire of the Triple Kirks. In 1866 the granite pride of the city was again dented by no less than Chairman of the Society of Arts. Aberdeen, he said, 'might have merits in the solidity of its granite houses, but it had the demerits of greater monotony and coldness of colour, and the hardness of the material ... [resulted in] absence of ornamentation.'

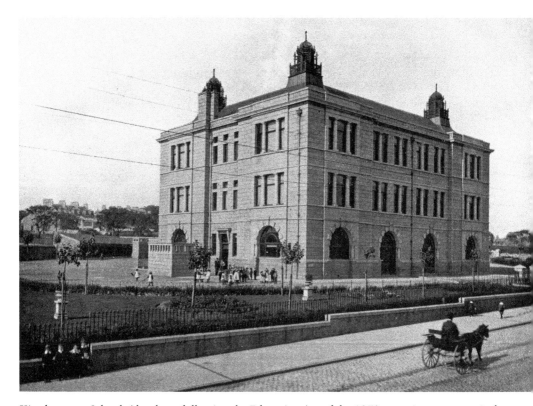

Kittybrewster School, Aberdeen: following the Education Act of the 1870s, granite was extensively employed in building schools across the city and Aberdeenshire, few finer than this example.

Regardless of the aesthetics there is no doubt that the industry supplied stone for the construction of better housing for genteel families with wealth. Whether it was on the line of Union Street or one of the carriageways to the north (Golden Square, perhaps), or south in the environs of Bon-Accord Crescent, comfort and elegance were to be found. What the granite industry of the era of Smith and Simpson failed to do was satisfy the need for decent lodgings to house the working classes or those at the very bottom of the social ladder, who led precarious lives in the worst of properties. The architects did address varying demands from clients and developers; for example at Victoria Street and Waverley Place, to the west of Union Street, quality housing was provided employing a granite rubble-build and a minimum of dressing, with the purchaser able to specify architectural flourishes such as an architrave at the doorway. For all their architectural modesty, these dwellings could have six bedrooms, parlours, dining rooms as well as gas and piped water.

This was the 1840s, the very time when one of the granite properties on Union Street became vacant following the death of James Hadden – textile manufacturer, Lord Provost and a leading voice in promotion of city improvement, and who was himself proprietor of stone quarries at Persley, where he promoted the use of chisels to augment dressing by pick and axe. Following his death in 1845 the house went up for sale, offering prospective purchasers a three-storey building with at least six bedrooms, drawing and dining rooms, a library, butler's room and, for more lowly servants, quarters in the attic. This was granite in quality and quantity.

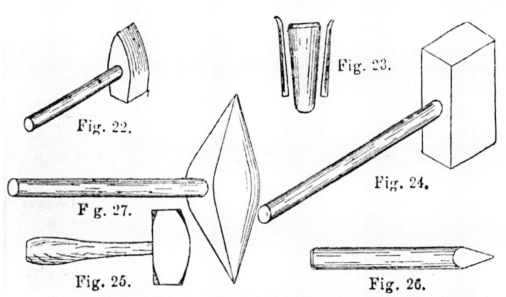

Fig. 22.—Hand Hammer·or Catchee. Fig. 23.—Plug and Feathers. Fig. 24.—Blocking Hammer. Fig. 25.—Maul or Mash. Fig. 26.—Point or Puncheon. Fig. 27.—Pick.

Mason's hand tools.

The granite industry had provided James Hadden with an income from his Persley quarries and a home of elegance and comfort, but not all who lived in Aberdeen were so fortunate. Those living at the lower rungs of the social ladder had access to houses with walls of the local stone, but the contrast between even the modest dwellings of Waverley Place and the upmarket Bon-Accord Crescent – let alone the home of the late Provost – could not be starker. The poorest in Aberdeen lived in properties that had long been abandoned by the wealthy. Durability of granite was no guarantee of quality. Among the worst were those found in the east end about Albion Street, for example, where in 1847 tenants lived in 'nauseous conditions' with as many as eight people occupying a room 9 feet square. In comparison, James Hadden's dining room was 25 feet by 9 feet. Two years previously, in a Rectorial Address at Marischal College, Archibald Alison praised the city for the 'magnificence and elegance of its architecture, the durability and beauty of the materials of which its superb buildings are composed'. This was not so in Albion Street and other areas of the Granite City where dilapidation reigned. In 1859 the town erected temporary hoardings to hide the decaying housing visible from the south balustrade of Union Bridge. The occasion was the opening of proceedings of the British Association with Prince Albert, processing west to the Music Hall.

Not every visitor was blind to the contrast of poverty of housing in the midst of splendour. The sparkle of granite's quartz and mica did not dazzle correspondent 'Peregrinus', who in 1846 advised observers not to be fooled by the quality of the architecture on Union Street and King Street, for behind the wealth could be found another Aberdeen. As he put it, to perceive only the sparkle was equivalent to seeing 'the Highlander's cap and feather, but not his kilt and bare legs'. Newspaper correspondence on this topic was part of a larger attempt by a number of prominent businessmen and civic leaders, including Archibald Simpson, to push through further city improvements. In the event the grand project did not happen and Peregrinus damned Aberdeen for lacking ambition. However, it is highly questionable if working and poorer classes would have seen any immediate benefits if the scheme had been adopted. Simpson himself made clear that the sweeping away of 'crowded and unhealthy' houses would put new building land on the market, which could generate a 'fair return' for developers, and not necessarily ease the problem of overcrowding for the poor. Improvement, as it was called, brought with it demolition and overcrowding.

Like Peregrinus, in 1865 *The Builder* could recognise the virtues of the granite industry and see that the benefits being wrought at one end of the social spectrum were being denied to others. When the Great North of Scotland Railway was pushing the line from Kittybrewster through the Denburn valley, *The Builder* informed its readers that: 'The working classes have been crammed, in the most inexplicable manner, into the remaining houses, to the great injury of their health and morals. And ... families of a higher yet humble position, have been ejected from their houses and are at the moment forced to take refuge in the cells of the Bridewell, which is fortunately for the present not occupied by prisoners!'

If nothing else, those in the Bridewell were being housed in a castellated granite building (designed by James Burn) just off the extreme west end of Union Street, but this was little comfort one imagines to the dispossessed. *The Builder* viewed the lack of decent housing as the disgrace of Aberdeen and even went so far as to advise that

if building granite housing was too expensive then the town should adopt common brick as a building material, or even think about importing Deeside timber for wooden dwellings, 'as their forefathers did before them'.

In the end, at least until the later nineteenth century, the challenge of good granite housing for the working classes was only taken up sporadically. Largely dictated by forces of the market place, scattered developments went ahead, with, for example, the Aberdeen Building Company being established in 1877, founded on the principle of generating a return on investment with the expectation that working men would be encouraged to buy flats. By 1879 it had overseen the erection of two tenements with inside toilets and wash houses at Urquhart Road. Its guiding policy was framed by the notion that 'working men were not in a position to pay extravagant prices for houses ... and they must endeavour as far as they possibly could to get efficiency and comfort and health for as little as possible.'

Matters in the centre of the town reached desperation, at least for those forced to live in appalling conditions, and slum clearance became the cry of the day. In 1886 Provost Matthews damned the 'wretched' houses on the Gallowgate and asked that new tenements be built 'specially suited both in accommodation and rental for the poorest classes'. Preliminary to clearance, houses were emptied and tenants made homeless. Some decided to squat, vacated buildings becoming, according to the Provost, 'the resort of the owls and bats of society'. He went so far as to suggest that with the failure of private capital to provide necessary housing, the town might take on the responsibility of housing working classes. A decade was to pass before even the smallest a move was made in this direction.

Gradually tenement building by private capital gathered pace. Thousands of tons of granite were taken from quarries, particularly Rubislaw. Following the proposal in the 1870s to build a road bridge to Torry – completed in granite in 1881 – attention turned to the rising ground to the south of the city where land was cheaper. The City of Aberdeen Land Association became a key player, promoting Torry as a coming place for industry and housing for the expected workers. By 1883 Torry was being spoken of as 'another Birkenhead', Aberdeen's industrial-residential suburb across the river.

Gradually, and with much manoeuvring by the Land Association, Victoria Road, Walker Road and Sinclair Road were developed. A mix of properties went up, at times standing in sharp contrast to some of the poorer dwellings in the older fishing village of Torry. 'Spick-and-span modern buildings', as the *Aberdeen Journal* put it, standing to the south, eclipsing the old village. Tall tenements were built, some with six flats and others with eight. A Captain Taylor described them as 'big castles'; to reach the topmost flats 'was like getting up to a ship's masthead'. Whether it was the stiff climb to the top of the common staircase or a more comprehensive critique of tenement life, Captain Taylor suggested that 'workmen's cottages' be built rather than tall shared dwellings (medical officer of health Dr Matthew Hay also favoured cottage style accommodation). But the economics of house building gave Torry its tall granite landscape. Witnessing the slow march of New Torry tenements to the south, the inhabitants of the fishing village found themselves confronted not only by the sparkle of freshly dressed granite, but also the emergence of an increasingly large local labour force servicing a steam trawling industry that was anathema to the ways of the villagers.

New Torry provided better and more salubrious conditions than the decaying parts of Aberdeen's east end. Tenements were supplied with water and improved sanitation, as well as wash houses and coal cellars; bathrooms, however, were a luxury too far for working class tenants. Where economy was key developers eschewed ornate decoration of granite, as the *Aberdeen Journal* put it: 'With the rush and hurry of trade it has sometimes been complained that architectural form has been sacrificed to utility and economy ... but ... most buildings have some feature which redeems them from absolute plainness.'

Elsewhere in Aberdeen one tenement did buck the trend in an extravagant fashion, namely the property at the corner of Baker Street and Rosemount Viaduct. Speculatively built by grocer and evangelical Christian William Salter, and designed by James Souttar using granite from Syllavethy and Kemnay, this multi-flatted edifice took its inspiration from Scottish Baronial and Gothic forms, made fashionable by Victoria and Albert's Balmoral Castle (also granite) and more flamboyantly presented by Souttar in the Salvation Army Citadel of the 1890s. With its corbelled features, ornamental towers and the use of decorative fish-scale slates, this block brought the elegance of stone to the fore, but of course at a price. It was estimated to have cost about £8,000 to erect, which meant the superior flats looked for tenants in a higher income bracket than many of those looking for accommodation in Torry.

Several tenement proposals included what otherwise would have been seen as luxuries. In 1894, for example, the Northern Cooperative Company put forward its plans for new shops and tenement housing in Rosemount, trumpeting that the fine new

Detail of Rosemount, James Souttar's impressive tenement block.

The utilitarian rears of Rosemount Viaduct's six-storey-high tenements.

granite building would give tenants baths and circulating hot water. A stone's throw away the friendly society the Ancient Order of Foresters promoted a similar policy at Esslemont Avenue, looking to provide wash houses and bathroom facilities. In the event it seems that like almost all of Aberdeen's tenement flats, bathrooms remained a wish list item rather than a fact.

Working class families with steady incomes did gain with the rise of new tenements. Streets away from the old centre began to take on that granite vista, which to this day still dominates Aberdeen's immediate suburbs. Speculative building was particularly vigorous in the 1890s, to the extent that by the end of the century many were claiming that the town was 'overbuilt', with too much property chasing too few tenants. However, those being evicted during slum clearance and the demolition of Longacre in preparation to construct the colossal granite masterpiece of new Marischal College would doubtless have welcomed a new flat. No provision was made to house them, however – a failure to act described by the local press as 'a most inhuman proceeding'. Thrown on the streets with few resources, the granite tenements in Torry and Rosemount were beyond their means. The poor themselves adopted various stratagems to cope with the catastrophic actions of the town council and university, including 'occupying' police offices and pleading for help. At the other end of the political scale the town council discussed the provision of council housing and a 'model' lodging house. But as well-meaning as this might have been, the eventual result was gestural building of tenement blocks at Urquhart Road, described by Brogden as 'more a commentary on frugality and charity' than an answer to the housing problem.

In the 1920s and 1930s, smart, square, four-flatted granite council properties were built, providing homes with bathrooms and many of the conveniences once deemed to be luxuries beyond the right of tenement dwellers. This went some way to relieving overcrowding across working class areas but it took the building of vast schemes post-1945 to make a significant dent in the housing problems of Aberdeen. As regards the granite industry's contribution to this housing revolution, unlike in the 1880–90s

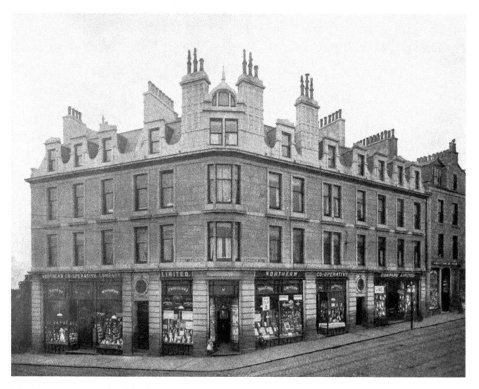

Northern Cooperative block, Rosemount.

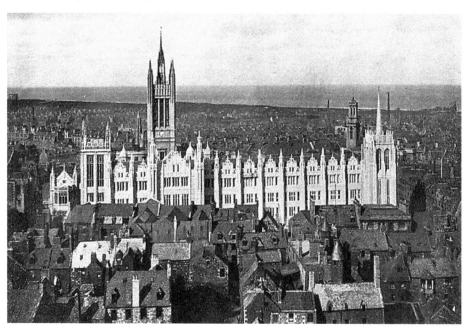

Marischal College. The unrestrained frontage by A. Marshall Mackenzie towers over the humbler tenements of the Guestrow.

Detail of a Kemnay granite finial in the process of being restored during refurbishment of Marischal College. This fine edifice was dressed in the era of pneumatic tools, unlike the architecture of Smith and Simpson. (Courtesy of Rosalyn Downes)

it was minimal as concrete and brick replaced local stone, although some housing on the Kincorth scheme south of the River Dee did use the hard stone – a deliberate policy adopted by the town council to enhance the landscape and provide employment for the granite industry. But by the mid-1950s, with a difference of £300 per house separating stone from the cheaper alternative of brick, the economic tide was turning against granite. The era of granite housing for the working class was passing.

Chapter 4

Caa'in the Big Wheel, Steam and Imperial Polish

Having paved the streets and shown the glories of architectural granite, the next move of the stone industry was to enter a far from new market, supplying stone for monumental purposes. This was to be a moment of revolution when steam rather than the brawny arms of cutters would drive the industry forward.

The granite industry was late in coming to the steam party – thirty years after Aberdeen's Forbes, Low at its Poynernook cotton factory first introduced its 'beautiful' 20 hp engine to the North East. Alexander Macdonald took the initiative. A mason to trade, the Perthshire man came to Aberdeen sometime about 1820 and opened a

Alexander Macdonald memorial, Nellfield Cemetery.

'small pavement yard' as 'marble and stonecutter' on King Street, within sight of the modish granite architecture of Smith and Simpson. For a decade he seems to have been content to work in marble and freestone, selling fashionable headstones, hearths and other items to a middle class clientele. Then, in about 1830 Macdonald moved to new premises on the east side of the street, making way for building of John Smith's imposing North Church.

Macdonald had years of experience in cutting marble and knew there was a ready market for luxury stone. He recognised that as hard as granite was, it could take a polish. As early as 1770 an Aberdeen jeweller had been offering customers polished granite trinkets. Alexander focused on how he might take the abundant local stone and manufacture bigger, bolder monumental works. The key was accelerating the process of polishing. Inspiration, so the story goes, came from examples of Egyptian granite art held in the British Museum.

As early as 1821 a letter to the *Aberdeen Journal* drew attention to an article in the *Edinburgh Philosophical Journal*, describing granite polishing in India, which, the author conjectured, had been a skill acquired from Egypt. The method of polishing was a laborious manual technique reserved for monuments to persons of high rank. It

Like Alexander Macdonald, jeweller Rettie & Sons entered granite work to the 1851 Great Exhibition and used their success to promote granite as decorative art.

would be more than a decade before granite polishing was introduced as an industrial technique, but it is telling that there was a local mood for exploring further advance in stonecutting. Moreover, the writer explained to the granite trade, the Indian mode of dressing stone was with hammer and chisel.

Egyptian art was brought to the attention of a literate European public through the writings of Vivan Denon, French artist and diplomat, who accompanied Napoleon on his invasion of Egypt. Examples of the art were later excavated by Giovanni Battista Belzoni with notable examples going into the collections of the British Museum. These artefacts, some of colossal dimensions, included polished granite specimens. Macdonald apparently visited the museum and viewed the stones. The British Museum held, for example, a four-sided red granite work almost 6 feet high, with polished carved figures and a red granite arm, thought to be part of a monument to Amenhotep III. We can imagine that, on seeing this anatomically bold fragment, Alexander agreeing with the museum guide that it was 'a wonderful piece of execution'. Both granite specimens had been acquired in 1823. In his *Lectures on Sculpture* (1829) the artist John Flaxman reflected on Egyptian art: 'If we consider the execution of a statue sixty-five feet high in so hard a material as granite, the bolder heart would be appalled at the incalculable labour and difficulties of the work.' He concluded, the 'Egyptian sculptors astonish us by their indefatigable labour.' Irrespective of the claimed 'universal monotony of resemblance', Flaxman recommended that all interested in sculpture should visit the collections of Egyptian art in the British Museum.

The problem faced by the Perthshire stonecutter was making granite polishing economically viable. Unlike Egyptian monumental works, Macdonald's wares were commodities, objects manufactured for sale. Not available to him was the luxury of an endless supply of labour, slowly but surely reducing rough-dressed surfaces to a polish, regardless of financial cost. Workers' wages had to be paid and customers found. Mechanisation was the answer. Just a short walk from his yard he could witness the marvels of the millwright, with belts, pulleys and gearing easing and speeding the work of brewing and meal-milling.

About 1832 Alexander appears to have experimented with the most basic of prototype polisher, with manual labour and ten-year-old William Mearns given the job of feeding sea sand and water beneath a polishing head, as Mearns recalled many years later: 'I was a little loonie. There was no machinery, but two old soldiers ca'd a big wheel, and I was pittin' on the stuff same as I'm deein' now.' This was a reminiscence of 1894 when, at seventy-two years old, William Mearns was still at Macdonald's polishing works.

Macdonald's next move was to apply more power to the mechanism. Unsurprisingly, steam was his choice. He was fortunate in that his yard was adjacent to a combworks owned by John Stewart and Joseph Rowell. The comb-makers had a steam engine and what could be easier than having the help of his neighbour? Some forty years after the event, John Stewart recalled: 'From my steam engine was supplied a belt to the late Mr Macdonald, being the first application of steam to granite polishing in Aberdeen', and worth saying probably first in the world. Polished granite is now ubiquitous but to all who saw the product of the 1830s it was surely a wonder.

Granite manufacture had entered the mechanised age with Alexander offering a very select clientele opportunities to purchase elegant works of art such as vases, urns, headstones and polished columns. So successful was the move to steam that before the

1830s were out he relocated to more commodious purpose-built premises on Constitution Street, by Aberdeen Canal and close to the Town Links, making the collection of polishing sea sand (with permission from the Council) that much easier. Additional capital for the expanding firm came when the stonecutter entered into a partnership with William Leslie, the builder responsible for the North Church on King Street.

The application of steam to polishing flat and cylindrical surfaces was extended by Macdonald to solve the problem of sawing granite. Quarrymen and builders had long used the plug and feather technique of splitting granite. As good as this was, it was not best for manufacturing large plane surfaces to be polished. Macdonald's answer was steam, iron with abrasive sand and water. With a swinging pendulum motion, an iron blade made its way through granite. This was no mass market product, as sawing remained a painfully slow process. Two decades after steam had first been applied a blade still took ten hours to cut through two thirds of an inch of granite, which meant about ten weeks of effort for a 4-foot-high block. Macdonald's 'beautiful and enduring stone' was intended, as an 1840s advertisement put it, for 'noblemen and gentlemen'; only they could aspire to have stone that 'retains its Polish most perfectly under all Atmospheric changes, does not Contract any stains from Vegetation, and unless wantonly Mutilated, will transmit the Inscription Engraven [sic] on it to distant Ages'.

A new granite industry promised objects of beauty and some kind of immortality. Not for those who chose to be remembered in granite the threat of a memorial stone flaking and disintegrating. It was bad enough that the body should moulder, but worse that eminence in life be forgotten. And make no mistake, granite went on to mark the achievements and passing of the Great and the Good.

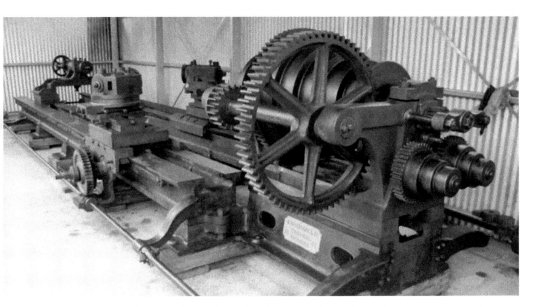

A granite turning lathe manufactured in Aberdeen 1881 by J. Abernethy & Co. It is now in New Zealand, where it has been cleaned and preserved. (Reproduced by kind permission of Moruya Antique Tractor & Machinery Assn. Inc.)

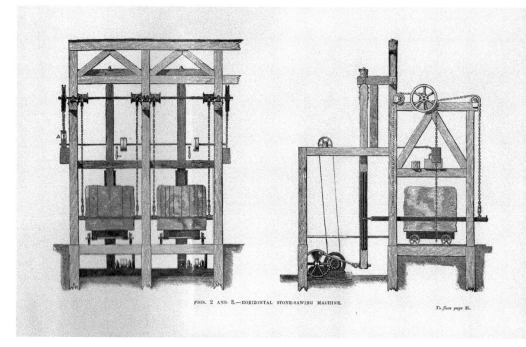

FIGS. 2 AND 3.—HORIZONTAL STONE-SAWING MACHINE.

To face page 35.

A multi-blade stone cutting saw of the 1880s.

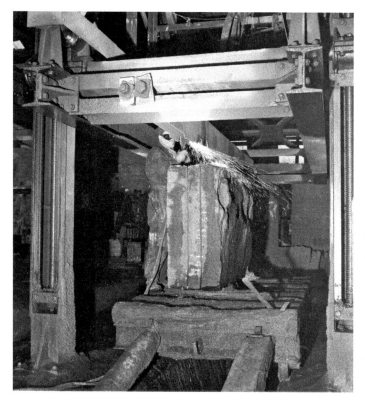

Burning 'teeth' on granite saw blades at Charles McDonald Froghall Works, Jute Street, Aberdeen. (Image part of a collection donated by Mr Hugh O'Neill. Reproduced with permission of British Geological Survey. Permit number CP18/008)

Macdonald & Leslie became the most prestigious and innovative granite business in the early decades of Victoria's reign. Having William Leslie as his partner brought Alexander new investment and entry to the building industry; until the partnership was dissolved in the 1850s, they supplied dressed and polished stone to construction, decorative and monumental work. The former included contracts at the Union Street Market, widening of the Bridge of Dee and the railway viaduct over the river at Polmuir, all contributing to the credentials of the company as well as the viability of granite.

Granite's new aesthetic reputation was built on its treatment as an ornamental and commemorative stone – such as tombstones, monolithic pedestals and decorative fountains. All could and were used to build a vision of civic and national pride and legitimise privilege. One of the earliest to be given the granite treatment by Macdonald & Leslie was Sir Walter Scott, novelist and antiquarian. In 1846, fourteen years after Scott's death, polished red granite from Stirling Hill by Peterhead formed the centre of a memorial at Dryburgh Abbey, with the stone being chosen by the sculptor Chantrey for its resistance to storms, so it '[would] defy such assaults and baffle time itself'. Earlier in the decade Stirling Hill red granite had been sent to London to adorn Trafalgar Square in the form of polished basins for fountains at the base of Nelson's Column – another national hero celebrated. Apart from simply enhancing Nelson's monument, the

Liverpool drinking fountain, 1856. Macdonald & Leslie made their own contribution to the health of poorer classes when they gifted or sold at cost (as they did for Liverpool) polished granite drinking fountains – a boon in an era of cholera and polluted waters.

One of the Liverpool Fountains.

Tomb in memory of Sir Walter Scott, Dryburgh Abbey.

fountains had the additional utility of reducing the assembly space at the square, which, with the ruling class's fear of radicalism and Chartism, was welcomed. It was said by the *Illustrated London News* that the polished stone could 'rival the rich flesh coloured granites of Egypt', a compliment which must have pleased Alexander Macdonald.

Thus one hero of the Napoleonic Wars was commemorated and soon after in 1844 that still living champion of British interests the Duke of Wellington was also celebrated with a bronze statue by Chantrey and Weekes, placed on a red and grey granite plinth. Macdonald & Leslie supplied the stone but it was a near-run thing, as the general might have said. The stone only arrived in London on 15 June, with the unveiling set for the anniversary on the 18th. It did arrive in time, but lacking an inscription.

These were all seals of approval which went a long way in promoting the desirability of granite, whether as a graveyard headstone or monument in a public square. At the Great Exhibition of 1851, Macdonald & Leslie submitted examples of their work. Despite the opinion of one writer that Aberdeen's contribution, while being superb examples of cutting and polishing, lacked the visual colour strength of granite from Cornwall, and regardless of another writer who claimed the city's granite had been 'placed in rather a dark corner', Macdonald & Leslie won a medal for the quality of their work. Prince Albert, keenly interested in industry and design, and a force behind the Great Exhibition, before travelling on to Balmoral had in 1848 visited the granite

Alexander Macdonald Junior's family sarcophagus, with Egyptian motifs, at the Kirkyard of St Machar.

[214]

MACDONALD, ALEXANDER, *Polished Granite Works, Aberdeen.*—Specimens of granite used in building, decoration, memorials, and general purposes.

[Obtained the Prize Medal in Class XXVII., in 1851; and the Silver Medal in Paris, in Class XIV., in 1855.]

No. 1. Polished red granite jointed Doric column, showing the closeness of, and flush surfaces of joints, when built in pieces by the exhibitor's patent process. In this way constructive and decorative erections of any size or form are made.

No. 2. Polished red granite pedestals for busts, vases, groups, &c.

No. 3. Gray granite Gothic headstone memorial, showing "fine axing," and the contrast between axed and polished surfaces.

No. 4. Polished red and blue granite Gothic baptismal font.

No. 5. Polished blue granite tomb,—specimen of cemetery memorial, which will retain its colour and polish under all atmospheric changes. Made of same granite as the sarcophagus executed for H.R.H. the Duchess of Kent's tomb at Frogmore.

No. 6. Polished red granite chimney-piece for public rooms. The polish and colour cannot be destroyed by smoke, or in any other way. Two large slabs, vases, and circular shafts, showing the material, red and blue.

No. 7. (Placed in court between Mineral and Agricultural Departments.) Polished red granite public drinking-fountain in operation. By experience granite is found effectually to withstand the action of water and frost, and not to contract any stain from vegetation.

Catalogue entry for Alexander Macdonald's submission to the London International Exhibition, 1862.

yard on Constitution Street. Fifteen years later the yard had the melancholy task of manufacturing the sarcophagus for Prince Albert. Supervised by James Ross an 18-ton block was quarried at Cairngall, placed on a low-load waggon and drawn by sixteen horses to the railway station at Peterhead, thence taken to Aberdeen. The death of the Prince Consort in 1861 was a moment in the creation of the modern British monarchy, with feelings of grief and loss providing sentiments around which the population of the United Kingdom could come together to rise above divisions of history and class, or so it was hoped. While Albert's death brought grief to Victoria, in its wake came orders for granite pedestals to display works commemorating the life of the Prince.

With Victoria and Albert taking up residence at Balmoral in the 1840s, Aberdeen had established strong links with the Royal Family, so it is not surprising that in the year that the sarcophagus stone was quarried the city unveiled a bronze statue in the Prince's memory. With a red and grey granite base, the sculpture by Marochetti depicted the Prince in state dress and not full Highland costume as initially proposed. In the same year, 1863, Victoria suggested that a national memorial should take the form of a massive granite obelisk. Her wishes, however, were confounded as the industry in Aberdeen and beyond was unable to supply the project with stone of sufficient dimensions.

As appreciative as Macdonald & Leslie must have been for memorial commissions, there was surely some sense of disappointment with granite being used mainly as pedestal material. Alexander imagined granite becoming the stone of choice for sculptors. With

A bronze statue of Prince Albert on a granite pedestal by Macdonald & Leslie.

the knowledge that Egyptian stonecutters had not only successfully polished granite but more impressively had carved large elaborate figures in this difficult stone, Macdonald set about demonstrating that he could supervise equally impressive work. And so it was that anyone wandering down Constitution Street in late 1840 might have seen in Macdonald's yard a 17-ton monolith quarried at Dancing Cairn. According to a newspaper report 100 men and a specially built waggon pulled by ten horses were needed to transport the stone safely to the city. From this Macdonald cut a figure some 10 feet high representing George Gordon, 5th Duke of Gordon. On Gordon's death in 1836 a subscription was raised to celebrate his memory, although, given his opposition to the reform of Parliament, it was probably not universally acclaimed. The sculptor Campbell was given the job of designing and modelling the work, which was to be erected in Castle Street – the heart of the civic and commercial community. According to Robert Fergusson, then an apprentice and later manager and partner at Macdonald's, Campbell entrusted the cutting to local men Alexander Chalmers and James Mann, being himself more familiar with marble. The sculptor's contribution, apart from the design and model, was 'the performance of taking a chisel and doing a few scrapings to bring out the artistic effect'. A special shed built at the Constitution Street works for housing the statue was for many years known as the 'Duke's House'.

A granite statue of the
5th Duke of Gordon.

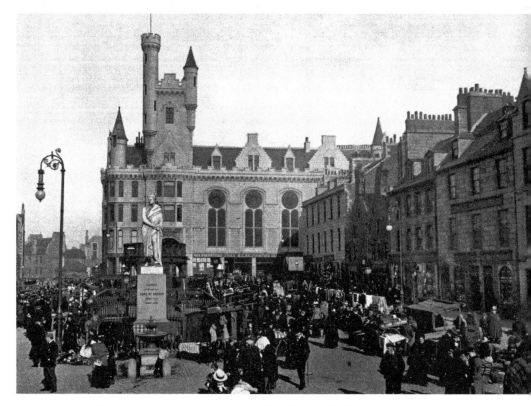

Aberdeen's Castlegate with the Salvation Army Citadel and the Duke of Gordon statue on its original site.

Standing on a block of red unpolished Stirling Hill stone, the statue, reputed to be the first of its kind to be cut since Egyptian antiquity, was erected in April 1844 and was the pride of the city and the stone trade. Local pride was one thing; actually generating orders for statuary of such quality and dimension was quite another. In the end granite never challenged bronze or marble as materials of first choice for sculptors. Granite, we might say, was 'relegated' to being the largely unseen pedestal for supporting local and national heroes. However, it was not that Gordon was the only large granite statuary cut in Aberdeen, and commissions did come; for example, a more than life-sized statue of Edward VII and memorials to the war dead of 1914–18 were erected. Despite its ability to withstand the rigours of climate, some believed that the aesthetics of granite statuary were wrong. One commentator of 1866 said it 'was all very well for the Egyptians ... But it will not do for the present stage of civilization'. 'Granite's weakness', he said, '[was] the stone's crystalline structure which could result in a crystal of quartz protruding in the one eyeball ... a circular spot of red felspar[sic] glittering on the tip of the nose.' He concluded that a statue should be 'cut from a block of homogeneous rock', preferably marble. On the other hand, granite was eminently suitable for architecture and cemetery memorials, and it was the latter market that became the new staple of the industry.

The Kirkton of Tough war memorial.

While Macdonald & Leslie had been the first kids on the block with steam sawing and polishing, others followed, bringing competition to the industry. First in the field was James Wright, who in 1850 moved into premises on John Street and introduced what he described as 'improved machinery', enabling him to sell sawn and polished granite 'at a remarkable cheap rate'. Competition gradually changed the structure of the monumental industry. James Wright expanded his works and went into partnership with John Beaton, who had been the Macdonald & Leslie London agent. Products of quality came from the yard; for instance, in 1855 he was manufacturing polished

granite and marble chimneypieces for the new Balmoral Castle. Wright's reputation blossomed and he was commissioned to supply the granite shaft for the important 'Old Westminsters' memorial for Broad Sanctuary, London. At almost 30 feet tall and designed by Sir George Gilbert Scott, the column was yet another marker of imperial actions – in this instance the deaths of men in Crimea and India; a prestigious contract. So proud was James that he encouraged the public to view the stone before it was shipped to London. The original design had called for a shaft composed of three sections. However, it became clear that finding such monolithic pieces of uniform hue presented an insuperable problem to the quarriers, forcing the selection committee into accepting a column made up smaller sections. Wright's exertions were rewarded in 1863 when he was appointed 'Manufacturer of polished granite in Aberdeen in ordinary' to Queen Victoria.

When the column was erected in 1861, Aberdeen's granite industry had made a leap into a new world of manufacture, which was eventually characterised by the appearance of numerous yards producing stone funerary ornaments and headstones. From the 1850s there was an expanding city-wide network of manufacturers, suppliers and agents competing for an ever-expanding market in cemetery memorials. Costs lowered as technology improved and production of thinner slabs became possible, feeding and encouraging the market in headstones. A walk through many of the country's cemeteries reveals that after the mid-nineteenth century granite became the stone of choice, with a corresponding decline in the use of freestone, radically altering the appearance of graveyards.

JOHN STREET
Polished Granite and Marble Works.

JAMES WRIGHT returns his sincere thanks to his numerous Friends and Customers for the very liberal share of patronage he has received since he commenced working by steam power, (by which he has been enabled to execute all orders with punctuality,) and begs to assure them that no exertion on his part will be wanting to insure a continuance of their favours, which it ever will be his constant study to merit.

At the same time, he would solicit their inspection of his present stock of POLISHED GRANITE and MARBLE CHIMNEY PIECES (fitted with elegant Grates), TOMB-STONES, MONUMENTS, PEDESTALS, VASES, and Dundee and Caithness PAVEMENT. Also, his stock of Barley Mill STONES, Grinding and Ridge STONES, &c. The whole of which he is enabled to Sell at least ten per cent. under the usual charges.

Advert for James Wright's wares, 1850.

THE WESTMINSTER COLUMN.—Mr. Scott, Architect.

The Old Westminsters Monument, London.

One of the finest (1850) monuments produced by Macdonald & Leslie, with polished column and fine-axed lettered spiral commemorating Reformation martyr George Wishart, located at Fordoun Cemetery.

Chapter 5

Bringing Material from all Ends of the Earth

It is now the first decades of the twenty-first century and Aberdeen's granite industry lives on. Monumental stone, building stone and road materials are still being quarried or manufactured locally. Nonetheless, regardless of how enterprising and technologically advanced remaining businesses are, a cursory glance shows they are a pale shadow of an industry that was once one of the linchpins of the North East's economy. Diminished by local, national and international competition, at its productive zenith Aberdeen's granite industry was in fact beginning to display the symptoms of decline.

With the application of steam and the emergence of the monumental industry, the final structural piece was added to Aberdeen's stone trade. Development was gradual as monumental cutters more used to working softer material turned their attention to granite. Whereas the earlier phase was marked by production largely centred on quarries the new period saw the spread of stoneyards across the city with finished products, decorative and memorial, being sent out to customers from an urban industry.

The vanguard role of Macdonald & Leslie had highlighted the application of 'big' technology to stone processing, but the spread of the monumental trade was characterised for the greater part of its history as a very mixed bag of manufacturers. Stonecutters could enter the trade employing no more than one journeyman backed by an apprentice. If a cutter could purchase slabs, polished or rough, the manual dressing and letter-cutting skills of a small workforce were enough to meet the needs of individual customers. Little fixed capital was required. At the other end of the trading spectrum were those such as Macdonald & Leslie and James Wright, who invested in machinery and men, giving them the ability to manufacture larger works in granite, thus meeting the demands of substantial customers who might, for example, require multiple polished columns. Over thirty years after investing in the technology of polishing, Alexander Macdonald's yard continued to innovate, purchasing in 1873 a lathe with J. D. Brunton's patented revolving steel disc cutting tool, which was capable of turning columns at a faster rate, generating smoother better finished cylinders.

Listings in the *Aberdeen Post-Office Directory* give an indication of the advance of the trade: until 1840, Macdonald & Leslie described themselves as merchants in marble and granite, while all other stonecutters advertised as workers in the softer limestone. In the mid-1840s one Charles Nelson adopted the title of worker in granite. In the early 1850s

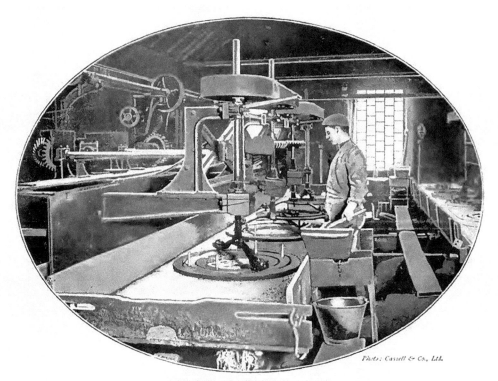

HOW THE GRANITE IS POLISHED.

Polishing *c.* 1900.

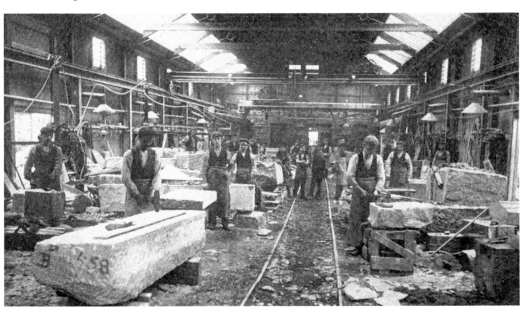

Granite yard *c.* 1900.

The Aberdeen Art Gallery Sculpture Court, with polished granite columns donated by members of the Aberdeen Granite Association. Stonecutters were encouraged to visit the Gallery to broaden their knowledge of aesthetics and to attend evening classes at the adjacent School of Art.

James Wright joined the list. Ten years later this had grown to eight businesses; in 1870 there were twenty-three; and a decade later over fifty firms advertised as working in granite, all in Aberdeen.

Industrial growth brought with it local and eventually international competition. Aberdeen had been able to establish itself as the gold standard centre for granite paving and the source for the best quality engineering stone. By the 1830s, when Alexander Macdonald introduced steam to the industry, the city's name was synonymous with granite. Skilled cutters could turn their expertise to architectural work and the needs of the monumental business. Thus the monumental branch of the industry was able to steal a march on stonecutters beyond Aberdeen, but there was no Klondike moment. Macdonald controlled the expensive technology, but as the fashion for decorative granite flourished and manufacture became more viable, so there was a steady trickle of new entrants

For four decades the few highly capitalised firms in the monumental and decorative stone trade enjoyed a virtual monopoly. High cost and high quality marked the industry and competition was kept to a minimum. However, time saw new entrants to the trade challenging the dominance of the old established businesses. Masons were returning from sojourns in America with dollars in their pockets, ready to invest in enterprises on their own account. This movement of labour 'across the pond' not only gave Scottish stonecutters the opportunity to acquire some capital for investment at home, but it also played no small part in the transfer of skills to the American market. Drawn by the prospect of higher wages many men gravitated to granite centres such as the Barre-Montpelier area of Vermont. Not all returned to their native North East; many went on to build monumental and quarrying businesses in competition with Aberdeen's industry. William Barclay, for instance, born at Fraserburgh and apprenticed as a stonecutter-builder at New Pitsligo, travelled in the mid-1870s to Canada, returned home for four years and then went to Quincy, Massachusetts. After various moves home and away he established what was to become Barclay Brothers of Barre.

The transfer of knowledge, however, was not one-way. As early as the 1820s Aberdeen Provost James Hadden had seen the bush hammer or patent axe being used on a visit to New York. On his return to Aberdeen he encouraged the local industry to adopt it.

THE LATE WILLIAM BARCLAY,
Founder of firm of Barclay Brothers, Barre, Vt.

William Barclay.

Initially rejected as no match for the pick, the axe was eventually adopted in the 1830s by Alexander Macdonald and became a standard stonecutting tool. Much later in the century, as the granite industry of the USA established itself, driven in part by the high costs of skilled labour and the need to speed and cheapen production, American manufacturers pressed forward with new technologies such as the Jenny Lind polisher, the stone dresser (Dunter) and pneumatic tools. All made their way eastward to Aberdeen, to be copied by local engineers.

Aberdeen's first demonstration of American pneumatic tools in 1895 drew together an expat cutter then resident in Philadelphia (Mr Christie), local engineer John M. Henderson and men from the granite industry. So novel was the apparatus that engineer Henderson had arranged for the power tool to be shown working in, of all places, William Thomson's lemonade factory. Linked to Thomson's 'carbonic acid chargers', Mr Christie from Philadelphia demonstrated carving and letter-cutting, claiming productivity six to eight times greater than men with hand tools. Within the space of a month leading carver Arthur Taylor had bought himself a gas engine to drive a compressor and was experimenting with the new tools. Cutting an ornate passion flower decoration on a cross of Rubislaw granite, he concluded that, yes, the pneumatic chisels carved faster than manual cutting, and just as delicately. The only drawback was the cost of the plant, which might be acceptable in the USA where wages were high, but in Aberdeen yards, where volume carving was only occasionally required, it was more profitable to stay with the old method. Being a carver, he, however, decided to keep the new technology.

The bush hammer head, the multi-bladed tool introduced from America in the 1820s. Depending upon the number of cutting blades, this hammer could produce the finest of dressed stone.

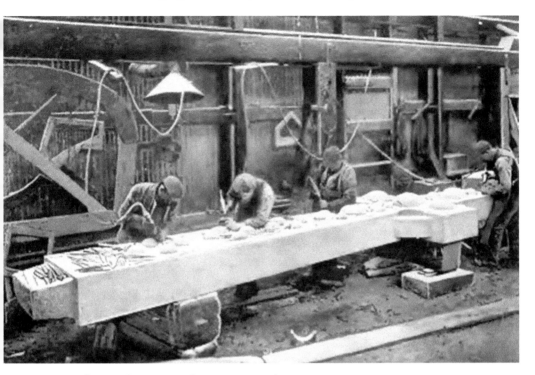

Carving a large Celtic cross with pneumatic tools.

Carved full-size figure in memory of Helen McDonald, wife of Arthur Taylor. Sadly, the torch that would have been in the right hand has been lost.

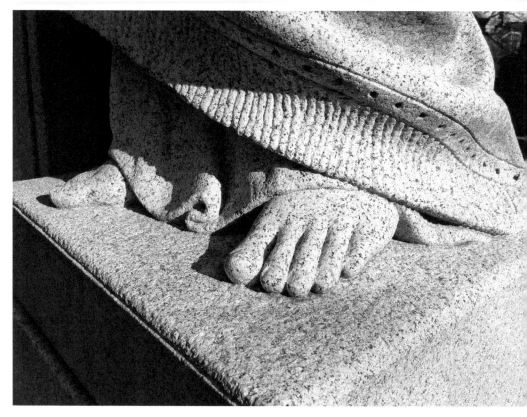

Detail of fine carving, by pneumatic tools, on an Arthur Taylor figure.

Skills and knowledge gained in Scotland had moved to the States, but this potential competition from American-Scottish manufacturers was a slow-burning fuse. Of more immediate concern to the established firms in Aberdeen, and their workforces, was the burgeoning of local producers, many of whom returned not only with dollars in their pockets, but also with knowledge of and contacts in the American trade. With little fixed capital the new men were able, it was claimed, to offer dressed monumental granite at prices below those of the larger firms – and worse, to establish themselves they made next to no profit from some jobs, described in 1886 by one merchant as 'shaving prices'. The happier days before the 1870s when merchants could set the price with little or no haggling from customers were, he said, long gone. There was also a shift in the customer base of the industry with what one newspaper editor described as 'the less moneyed classes' buying headstones. Granite had been a luxury product, expensive and fashionable, with the entry level for a granite gravestone being around the £50 to £60 bracket. The new manufacturers were offering stones from £6 to £30, which were within the reach of some working men and woman. One merchant, John Fraser, went so far as offering headstones for £2 5s. With their knowledge of the American trade the new enterprises built a network of American contacts who fed them orders, but always with pressure from the States for stones at bargain prices.

American granite merchants' adverts of 1889.

Firms with large investments in machinery complained that by working excessive overtime small manufacturers were unashamedly breaking unwritten rules of the industry, compounded by the renegades' willingness to entice cutters and polishers to 'moonlight' after finishing a day shift elsewhere. Men, it seems, were working the then normal nine or ten-hour day and going on to effectively undermine their main employer. Excessive hours being worked brought Aberdeen's Trade Council into the ring, saying it was injurious to health, particularly when young boys were being employed.

At the same time, pressing on the industry was tension between the quarrying sector and manufacturers. Aberdeen's trade was firmly established on the availability, beauty and durability of North East granite. With widening markets the trade found quarrymasters struggling to meet customers' needs. Local quarries endeavoured to satisfy the demand for high-quality stone; as a result, delivery times were stretched and manufacturers could be kept waiting months for suitable granite. Then, the unthinkable happened: foreign granite was imported. It was cheaper and available and in colours not found locally. Regardless of claims that foreign granite lacked the durability of Aberdeen stone, Scandinavian granite became fashionable and ever more cargoes arrived in Aberdeen

By 1888 the old monumental traders described the situation as one of crisis – not that they were without work; indeed, important large architectural and monumental contracts could only be done by them, and despite the sense of crisis in the industry 1887

Advert for Swedish granite, 1900.

was described as a year when the big firms were going 'full blast'. Nonetheless, the perceived crisis was the recognition of real changes across the local and international industry. So it was that two days before Christmas 1887 the leading granite merchants and others gathered at Airth's Hall on Market Street, intending to introduce control and stability to the trade. Quarrymaster John Fyfe was in the chair. In the event there was a lacklustre response to his and Charles McDonald's call for a coming together of the trade.

Far-sighted Charles McDonald pressed on and by February 1888 he had persuaded forty-eight merchants (manufacturers and quarriers) to sign up to the rules of the Aberdeen Granite Association. By the end of May, membership had grown to sixty-one firms. The inaugural dinner was the opportunity for members to voice complaints and point the finger at the villains of the piece: 'Certain parties [who] had gone down far below the live-and-let-live standard ... work done for nothing else than a selfish end.'

The Association formulated a set of rules designed to reduce local competition. A Price List was issued, setting out what members must charge for particular types of work; uniform rates of pay, hours of working, overtime allowed and the ratio of apprentices to journeyman were also defined. In addition, with the appearance of agents acting as middlemen for the retail trade in England, and particularly America, the Association tried to bring them under control by issuing a Black List of firms who attempted to circumvent the association's anti-competitive rules. Any member who transgressed could be expelled. The Aberdeen Granite Association was essentially a cartel of quarriers and manufacturers determined to hold back the pressures of local and international competition. One of the biggest ructions in the Association happened in 1912, when James Hadden of the Imperial Granite Works was victimised, accused of having sold stone below the price fixed in the bylaws. Dodging the rules of the Association had long been an open secret, but setting a hard face against Hadden, the Directors decided to expel him from the Association. A bitter row ensued, legal action was threatened, resignations followed and eventually the matter was resolved, with the Association accepting that inflexible price-fixing should be abandoned and competition was legitimate.

Missing from the story so far is the other side of the industry – its labour force. Without the voluntary or forced cooperation of its workers the Association's design was stymied. Labour across the granite trade comprised a multitude of skills: in quarries there were drillers, settmakers, masons, apprentices, labourers, blacksmiths, engine-men and others; the monumental building side was dominated by the skilled stonecutters with polishers, scabblers, turners, toolsmiths, apprentices and labourers lower down the hierarchy. Skills were gained through years of experience in identifying and handling the ways of stone. Employment fluctuated with demand and economic cycles, and like other trades men learned how to bargain with employers. Technological innovation brought new categories of workers into being and posed questions on the distribution of power within the industry.

Granite workers faced a multitude of problems ranging from the hazards of quarry work where fatalities and serious injury threatened such as rock falls, explosives, collapsing cranes and 'dead hands' from the use of pneumatic-steam drills. From 1831 countless hundreds of building and monumental workers attended Aberdeen's Ophthalmic Institution, eye protection not coming into vogue until the twentieth century.

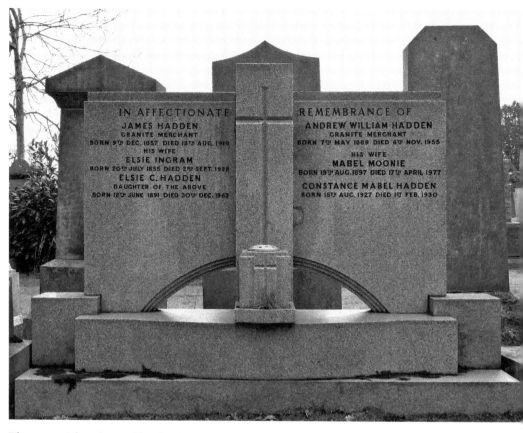

IN AFFECTIONATE
JAMES HADDEN
GRANITE MERCHANT
BORN 9TH DEC. 1857. DIED 18TH AUG. 1919
HIS WIFE
ELSIE INGRAM
BORN 20TH JULY 1855. DIED 2ND SEPT. 1928
ELSIE C. HADDEN
DAUGHTER OF THE ABOVE
BORN 12TH JUNE 1891. DIED 30TH DEC. 1963

REMEMBRANCE OF
ANDREW WILLIAM HADDEN
GRANITE MERCHANT
BORN 7TH MAY 1889. DIED 4TH NOV. 1955
HIS WIFE
MABEL MOONIE
BORN 19TH AUG. 1897. DIED 17TH APRIL 1977
CONSTANCE MABEL HADDEN
BORN 15TH AUG. 1927. DIED 1ST FEB. 1930

The memorial to the Hadden family, Springbank Cemetery.

Imperial Granite Works' open yard with range of polished memorials. (Courtesy Dr Hilary Hinton)

Andrew William Hadden, proprietor of Imperial Granite Works, Back Hilton Road, Aberdeen. (Courtesy Dr Hilary Hinton)

Nicky, the Imperial Granite Works dog. (Courtesy Dr Hilary Hinton)

In 1912 one in every two masons was treated for an eye injury. More insidious and dangerous was dust. Cutting granite in open air was less hazardous but in the 1890s many monumental yards introduced enclosed work sheds, a Janus-faced advance as it gave protection from the elements and at the same time intensified the clouds of dust, made worse as it coincided with the introduction of pneumatic tools. Swinging pendulum saws, revolving polishers, flying belts and noise added to the dangers. These hazardous working conditions might have been accepted as more or less integral to the to trade, but the question of wages, either as piece work or hourly rate, was more frequently challenged.

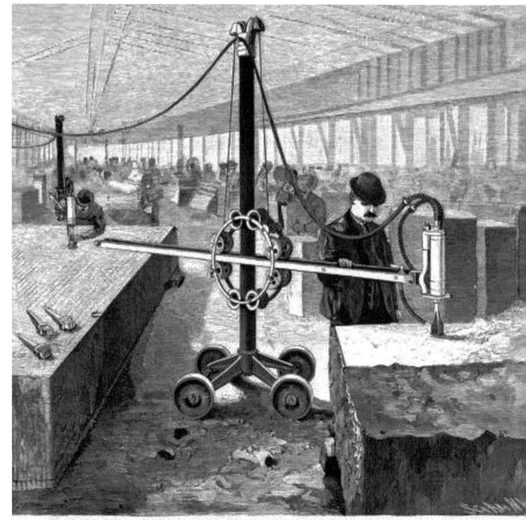

PORTABLE STONE DRESSING MACHINE OF THE AMERICAN PNEUMATIC TOOL COMPANY.

A portable stone dressing machine, 1894. This was American technology, and was known in Aberdeen as a Dunter (meaning to thump-strike).

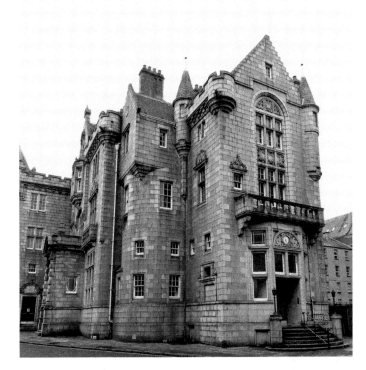

The Baronial style
Aberdeen Post Office
of 1907.

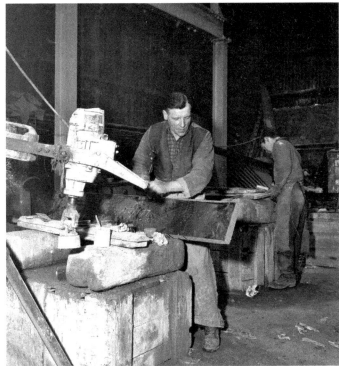

A small portable electric
polisher called the Seaton
Polisher, seen at Charles
McDonald Froghall Works,
Jute Street, Aberdeen.
(Image part of a collection
donated by Mr Hugh
O'Neill. Reproduced with
permission of British
Geological Survey. Permit
number CP18/008)

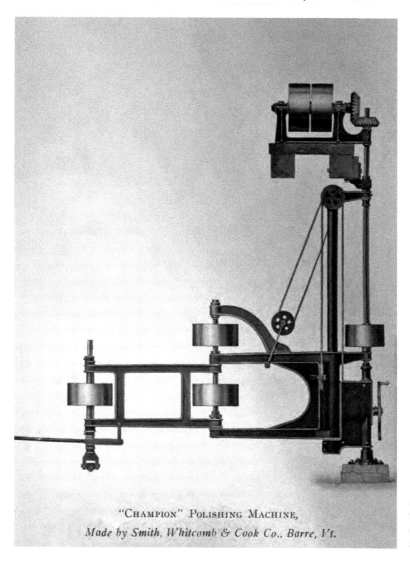

"CHAMPION" POLISHING MACHINE,
Made by Smith, Whitcomb & Cook Co., Barre, Vt.

American technology of the early twentieth century.

As early as 1768 quarrymen at Cove went on strike against a reduction in wages, but it was in the nineteenth century, with the expanded industrial base and when nationwide labour began to assert particular interests and identities, that working class unions in the granite trade begin to appear. With an industrial structure typified by relatively small units, and with considerable contact between labour and owner-managers, paternalism was frequent. In 1854 the polishers at Alexander Macdonald's yard placed an advertisement thanking their employer for the introduction of a half-holiday Saturday with no loss of pay and for an increase in their wage rate. Though it must be said this was no isolated act of benevolence, but was rather part of a citywide movement, including middle class advocates, which had seen other tradesmen winning the concession earlier than the polishers. Historian-mason William Diack stated that

Macdonald had begrudged the cut in hours as it 'crippled his business'. Given the volume of fashionable work that went through the entrepreneur's yard, there was little sign of crippling. The reduction gave men a fifty-seven-hour week.

Warned to avoid being influenced by 'discontented and turbulent individuals', more often than not organised labour found itself obstructed. In the 1830s and 1840s organisations came and went, but in 1865 masons garnered their strength to combine as the Aberdeen Operative Masons' Society. Seeking an extra half-penny an hour they took on employers. Being a busy season builders conceded one farthing with the promise of an equivalent increase in 1866, which duly happened, raising the hourly rate to 5½*d*. Whether the concession had irked some employers is not clear but in 1868 granite masons had their wages cut to 5*d*. Over 300 men went on strike. Employers were split, some continuing to pay the old rate. 200 men remained at work. Ten weeks into the dispute and only 190 men were on the strike-roll: masons had returned to work and over 100 had left the city. Settlement of the dispute had two particularly important outcomes. Firstly, the appointment of an arbiter to decide the hourly rate, the decision binding both parties. With the wisdom of Solomon, advocate John Duncan set the rate at 5¼*d* per hour. Secondly, the long, drawn out battle exhausted the Masons' Society and by 1872 it had dissolved.

Organised labour rose again in 1873 in the guise of a branch of the United Operative Masons' Association of Scotland. Four years later employers and union faced off as men demanded 8*d* per hour, a rise of half-penny. Militancy on both sides was firm. Employers refused to recognise the new union, saying that they only acknowledged the rights of the defunct Masons' Society. Strike action was set for the 1 June 1877. Employers threatened a lock-out which meant polishers were sent home. Arbitration was rejected by the union and the strike began. Eleven weeks it lasted and, in the words of mason John Annand, 'which for bitterness had scarcely ever been equalled in this quarter'. Labour was defeated and men returned on employers' terms, including once again the acceptance that future disputes should be settled by arbitration.

With hindsight we can see that the defeat of 1877 went a considerable way to moulding future labour relations in Aberdeen's granite trade. Drained in battle and profoundly weakened following a banking crash, the Masons' Association moved to cooperation with employers as a way forward. Both sides came together in 1880 to adopt a set of bylaws binding on union and employers. The laws set out hours of work (now a nine-hour day, from 6 a.m. to 5 p.m.), minimum hourly rate (now 6*d* and discretionary 6½*d*) and lengths of apprenticeship. When masons discussed these proposals there bubbled to the surface disagreement over whether a purely Aberdeen or National organisation was best. In the event this question was effectively answered with the collapse of the Aberdeen lodge of the Masons' Association.

In September 1888 the Aberdeen Trades Council took the initiative and called a meeting with the intention of re-forming a masons' trade union. The outcome was the birth of the Aberdeen Operative Masons' and Stonecutters' Society. Unaffiliated to any national union it became the core organisation around which granite labour revolved. Comprising only time-served building and monumental masons, however, it consigned all other workers to the periphery. Before twelve months were out membership stood at 814. Significantly, the new society was born within eight months of the founding of

John H. Elric of the United Operative
Masons and sometime President of
Aberdeen Trades Council.

the Aberdeen Granite Association. The two bodies met, and with the bylaws negotiated in 1880, began a process of mutual recognition. This did not take long: in February 1889 employers and labour formally accepted a new set of binding rules.

Hard on the heels of the new union came organised polishers – men who lacked the status of masons and stonecutters but who were crucial to the granite industry. The Polishers' Protective Union as it was called was held at arm's length by employers. Polishers worked a fifty-six-hour week, five hours more than stonecutters, and were employed on piece work. Their union wanted to establish improved working conditions and a trade-wide apprenticeship scheme; in return, it offered management of its members by enforcing a ban on men 'moonlighting', as well as accepting a month's cooling-off period when dispute threatened. This dragged on from 1889 until 1892, with employers still denying recognition. Patience exhausted, the polishers called a ban on overtime. Men were sacked and a strike was called. Employers responded with a lock-out. The Granite Association found its negotiating position weakened by internal dissent, and some employers favoured conciliation over confrontation. Resignations followed and when 300 polishers marched through Aberdeen streets they pointedly passed the yards of progressive employers Charles MacDonald, Arthur Taylor and Robert Simpson, where 'ringing cheers' were given.

The Granite Association lost public support and eventually agreed to negotiate. By May 1892 grudging recognition was given to the union and the men won concessions on overtime rates, but their working week was not brought into line with that of

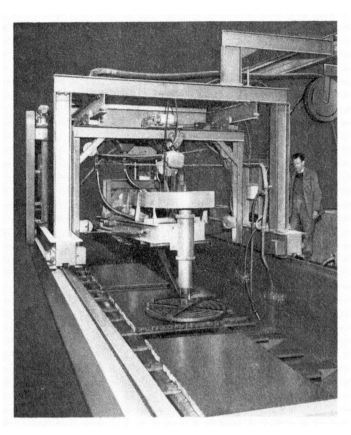

(4) **EAGLE**

This is a large loose abrasive Semi-Automatic Polishing Machine with all the features of the "Swallow" described above. The Rings are Cast Iron but vary from 18" - 54" dia. The Capacity of the "Eagle" is 30' Long x 6' 0" Wide and has a polishing potential of 10/15 sq.ft./hr. depending on the type of Stone.

George Cassie & Sons' polishing machine.

stonecutters. Throughout the dispute the masons' union did little to aid polishers; indeed, at the end of the dispute the Stonecutters' Society was accused of having instructed its apprentices to obey employers if told to operate polishing machines.

This dispute not only showed the potential strength of the men on machines, but highlighted differences across the industry. In their own ways, both sides were concerned with the impact of increased competition. Some employers conceived that the best way of ensuring competitiveness was holding back demands from labour. On the other hand, men such as Charles MacDonald looked to a more intensive use of machinery, which they believed would improve profit margins and at the same time provide better working conditions. The Polishers' Union damned local employers that entered into cut-throat competition, who, rather than improving productivity of man and machine, used overtime to extend productivity.

The conundrum of how best to exploit new technology dogged the industry into the twentieth century as labour and employers fought their respective corners. When pneumatic stone dressing machinery was introduced about 1901, apart from producing deadly dust, the Dunter, as it was called, brought to the fore the problem of mechanising what had been until then a manual task for qualified men. Masons feared de-skilling.

Following the procedure adopted in the USA, the union accepted the machines, but only if they were to be operated by skilled men; 'give and take' was the answer. At the other end of the business spectrum the Master Builders' Association told masons: 'In the march of progress somebody is always touched, and in this case it happens to be the operative stonecutter.'

The give and take within the local industry was exemplified in the introduction of a closed shop with the express intention of the union and the employers' association policing their respective members, keeping them in line with the bylaws. Industrial peace was not guaranteed, however. When conflict did occur it tended to be prolonged and bitter, as with the 1913 wage dispute, where 1,500 men were out and the strike lasted fifty-two days. The final settlement included the Polishers' Union being recognised by the Granite Association.

With the ever-present drive to keep productivity up and costs down, merchants introduced new carborundum saws in the 1950s. Employers wanted labourers to operate the machines, but masons argued for skilled men only. A strike followed, which was complicated by the fact that it was part of a larger Scotland-wide wage dispute. Negotiations resulted in an offer of a 3*d* per hour rise if masons conceded on carbo-saws, but Aberdeen's men held out to the dismay of national union officials, one saying that: 'The Aberdeen Union had been a law unto themselves but now his Executive would take the lead.'

If ever a moment indicated the loss of a strong tradition of local independence in the granite industry, this was it. New technologies had helped undermine the power of the skilled men who resisted, but did not stop the process. Whether it was the Dunter, carbo-saws or the wire saws that followed, masons found the tide was against them.

With hindsight it's easy to see the formation of the Granite Association in 1889 as a King Canute moment. No matter how hard the Association tried to promote 'a friendly feeling among its members', tensions and disagreements emerged as individual firms promoted their own immediate interests. Foreign granite imports, for example, led to numerous internal battles, such as W. C. Townsend taking in a red stone and describing it as Hill O' Fare Red, hoping to pass off the imported stone as local. This, naturally, brought howls of protest from Edward Hutcheon, owner of the Deeside quarry at Hill O' Fare. Under pressure from the Association, Townsend proposed Swedish Hill O' Fare, which was still not acceptable, and eventually he had to make do with Ruby Red. It so happened that the popular genuine red Hill O' Fare constantly hit difficulties in maintaining a supply of good stone. Edward Hutcheon hit poor rock, which meant costly opening of new areas and failure to meet clients' deadlines.

Hutcheon was not alone in feeling the pressure from foreign imports. Red Swedish stone was coming into Aberdeen between 10 and 40 per cent cheaper than red Peterhead. Following in Hutcheon's footsteps were the grey granite men: Fyfe of Kemnay and A. & F. Manuelle of Dancing Cairns, and the Rubislaw Granite Co. They came to the Association in 1895, attempting to halt the importation of stone when, as they put it, there was sufficient local supply. As early as 1892 about 7,000 tons of foreign stone was delivered to the local industry. William Martin of the Peterhead Great North of Scotland Granite Co. concluded that the trade was 'in a dangerous condition', what with importers 'bringing materials from all ends of the earth'.

But what might be an implicit threat to a quarryman was a boon to merchants focused on final manufacturing. For them imported stone was a necessity – so much so, and again with an eye to controlling trade and limiting competition, that in 1897 members of the Granite Association formed the Granite Supply Association. Two years later directors of the new cartel did what would have been unthinkable to the earlier trade: they travelled to northern Europe and Russia to source granite. Once again the panacea of control eventually came up against the imperative of competition, with Aberdeen finding that other European manufacturers, particularly German-based, were also after stone. However, visits to quarries were not always from Scotland to Scandinavia. In May 1896 builder John Morgan showed a Swedish quarrymaster around Rubislaw quarry, promoting the working practices and extolling the virtues of Aberdeen's granite trade.

With the Scottish-American connection, trade in the US market prospered. Tom Donnelly records that the value of headstones exported to America grew from 1880 until the early 1890s, rising from £12,343 to £33,040, and peaking at £89,341 in 1893. However, American manufacturers were unhappy at the success of the Aberdeen men and pushed for protection in the form of increased tariffs imposed on imported granite. Higher duties coupled to more efficient extraction, cutting, polishing and improved quality gave 'Yankee' merchants sufficient edge to begin to take a bigger share of US business.

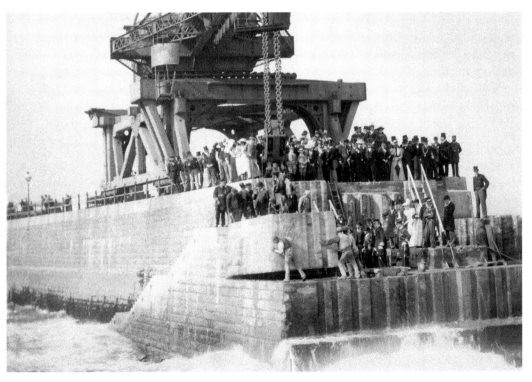

Roker Pier, Sunderland, 1895. For all the use of concrete at the heart of the pier, Kemnay granite from John Fyfe was specified as the outer bulwark for this large civil engineering project. (Courtesy Tyne & Wear Archives and Museums)

When granitecutter James Duncan returned briefly to his native North East in 1898 he brought the industry a wake-up message. Duncan was then secretary of the American Granite Cutters' National Union. It was no use, he said, continuing with old methods of working. Aberdeen's near monopoly was at an end and merchants need to produce 'monuments in a cheaper and quicker way', otherwise the industry 'could not compete with the greater granite centres in America ... [with] Barre ... at least ten years ahead of the trade'.

The Aberdeen Granite Association turned to America for support. From 1893 until 1899 it worked with Boston retailers, believing that by controlling prices and restricting the availability of granite both sides would benefit. Co-operation came to an end as individual retailers and Aberdeen manufacturers tussled for business. By the time they went their separate ways the value of headstone exports to America had fallen to £18,807. Nonetheless, exports to the USA did climb, reaching £35,082 in 1910. Twentieth-century trading, however, was at cut-throat prices. In the process, according to the American agents, Aberdeen began supplying second-class work, resulting in the retailers holding back on orders worth £10,000. The impact on monumental yards was immediate and dramatic, with 100 men being thrown out of work.

As the profitable US trade began to fall away the larger manufacturers found a new market, quite literally on high streets across Britain. Improved technology had brought down the cost of polishing and what was lost in the American market began to be filled by the new business for polished building fronts. What had been a novelty in 1860 when James Wright built a polished facade on his Rosemount home became the height of commercial fashion by the end of the century. Architects again looked to Aberdeen for fashionable stone, even if it was not always locally quarried: in 1891, Alexander Macdonald & Co. shipped red and green Swedish granite to London to adorn the front of Tiffany's on Regent Street.

Meanwhile, through the 1890s settmaking was still un-mechanised. This work provided quarries a steady, and at times very brisk demand. What with the laying and re-laying of tramlines and the spread of cassied streets beyond central thoroughfares, this decade was good for the industry, with John Fyfe taking over the lease at Tillyfourie, A. & F. Manuelle reopening their quarry at Dancing Cairns and James Leith leasing Craigenlow at Dunecht. With fluctuations from 1890 until 1899, setts exported by ship grew from 21,948 tons to 22,052 in 1896, and 39,948 tons in 1899, with settmaking showing 'remarkable prosperity'. Buoyed with enthusiasm the editor of the *Aberdeen Journal* informed his readers that the future was bright, particularly so with the introduction of the motor car. 'Leagues of granite causeway' would be laid, it was thought, as 'nothing but granite can resist heavy traffic'. Despite some cities such as Edinburgh buying imported setts, optimism remained high. One commentator's opinion was that: 'Taking all things into consideration, there is no need for getting scared of foreign imports as the superior quality of Aberdeen setts will command both a ready sale and a good price.' However optimistic this view was it must be said that at the time, 1902, prices were falling and quarries held large stocks of setts.

There were voices raised against complacency, perhaps no one clearer than W. A. Wight, manager at Dancing Cairns, who said the industry was 'too much like the three tailors of Tooley Street imagining themselves the centre of the world ... there had arisen many powerful syndicates and companies in opposition, seriously threatening the trade of Aberdeen.'

Decorative polished Peterhead granite at James Wright's Rosemount house. Built in 1860, it was probably the first town house to incorporate polished stone in a domestic facade.

In the midst of decline there were still moments when the glory that was Aberdeen's granite industry returned, and when its stone and workmanship was seen as second to none. War and commemoration of the countless hundreds of thousands men and woman lost in nineteenth and twentieth-century conflicts gave work and once again prestige to Aberdeen granite. For example, the Boer War at the end of Victoria's reign produced the opportunity to supply structures that will stand for all time as monuments of British supremacy. 'This war,' said William Boddie, 'has brought grist to the mill of the granite trade in the manufacture of memorials of fallen soldiers.'

Similarly, the First World War gave the industry the opportunity to produce some of the best carving to ever come out of Aberdeen. The Second World War called for more stone, although this tended to be constrained by the design set out by the War Graves Commission and memorials were erected locally rather than nationwide. There was at one point an unseemly dispute over price-fixing and questions over the quality of granite coming from the quarry at Inver.

During the First World War, granite, like so many other industries, made way for mobilisation. Munitions were wanted, not polished shop fronts, although the trade foresaw eventual high demand as Europe rebuilt. Men volunteered or were conscripted. Yards and quarries lost labour, merchants struggled to stay in business. Imports of granite dwindled, threatening to kill off the monumental business. Old retired men came

The Rhynie war memorial, 1920, cut by Robert Warrack Morrison. His skill and speed were such that he could sculpt a figure in as short a time as six weeks.

Robert Warrack Morrison, King of the Granite Carvers. (Courtesy Douglas Kynoch)

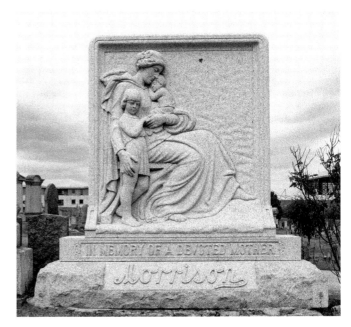

A fine family memorial carved by Robert Warrack Morrison, located at Trinity Cemetery.

Aberdeen's lion war memorial was cut from Kemnay granite by James Philip and George Cooper Clark.

back and women were drafted in, and no new investment was made. Coming out of the war, Aberdeen's granite industry, monumental and quarrying, was that much weaker, and into the 1920s its competitiveness was challenged by currency depreciation. In the midst of the hyperinflation of the early 1920s, German merchants were selling cut-price finished memorials in Britain, described by the *Press & Journal* as dumping. To little avail the Granite Association agitated for imposition of a stiff protective tariff.

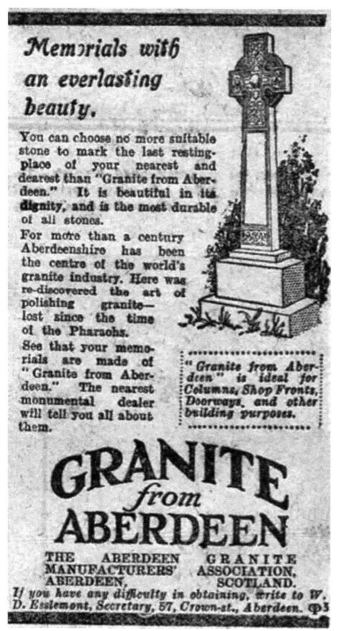

Granite Association advert of 1923.

Ironically, when the industry explored ways of improving efficiency in the 1930s, it was to the German trade it turned: a delegation visited Hitler's Germany in 1936, touring a quarry near Dresden where they saw technology unknown in Aberdeen. Rather than settmakers sitting at individual scathies, there was a veritable factory turning out thousands of setts. The Aberdeen men were impressed but engineer Frank Cassie said there was no chance of the machines successfully splitting Rubislaw or Sclattie stone.

Despite the clear pressure to improve productivity, the Aberdeen trade continued more or less as it had done for the previous fifty years, relying upon imported granite for monuments as well as for polished building frontages. Just before the outbreak

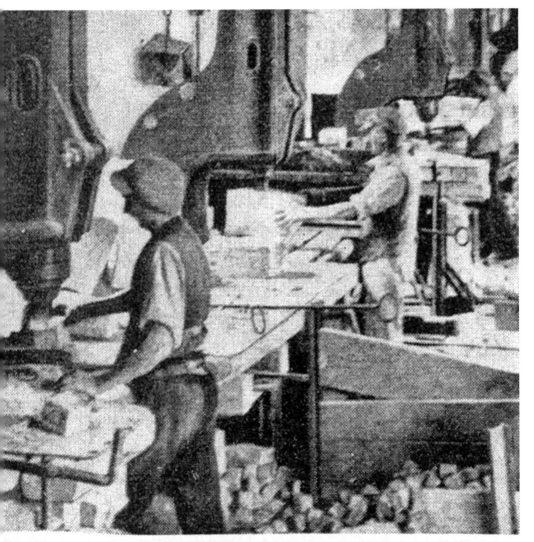

The mechanical settmaker at work.

Sett manufacture in Germany, 1936.

of war in 1939 the Granite Manufacturers' Association had briefly employed Ernst Freud to show merchants how to produce a 'mirror polish' – a highly reflective surface particularly popular on black granite. Of the city's forty-three firms surveyed at the outbreak of war in 1939, only two employed more than 100 men; the average was thirty-six, mostly small yards in cramped spaces. As for quarries, evidence of declining industrial importance was manifested in the shrinking workforce. From a high of just over 2,000 in 1900, employment overall had fallen by 1937 to fewer than 1,000, with even the mighty Kemnay showing a 50 per cent decrease. Needless to say, wartime demands again hit the industry hard with imports being stopped, labour and materials restricted and the building industry all but drying up. The shortage of labour intensified local competition, leading to disputes between businesses as they attempted to 'bribe' men to work for them.

Come peace in 1945, the industry was again that much weaker. Apart from ongoing problems of foreign imports of rough and dressed stone, there remained a difficulty in attracting labour – especially apprentices – to a trade characterised by heavy work, at times in the open, and which had gained a reputation for the dangers of dust inhalation. In 1946 employers and unions joined in a call for a ten-year ban on worked granite coming into Britain, but not, of course, on rough stone, as this was the reason for the existence of the Granite Supply Association.

Emulating the visit to Germany in 1936, a delegation visited the USA in 1948, where they saw the latest machinery in quarries and workshops. Despite being 'amazed' by the US industry, employers did little to face competition. Delegate member engineer Frank Cassie did turn his attention to designing new machinery to meet the industry's needs: circular saws, straight cut gang saws and polishers all eventually became products made by Cassie & Son. Manufacturers who looked to invest in new machinery needed confidence that the commitment would be profitable and that labour would cooperate by accepting new shift-working and agreeing to machines being minded by unskilled workers.

In 1962, like his father before him, Frank Cassie Junior addressed the Granite Association, arguing for a more far-sighted business strategy with greater co-operation between the twenty-three remaining monumental firms. But as John McLaren, manager of Bower & Florence, said in his memoir of the industry, it was too late for most businesses. Aberdeen granite was, he wrote, 'struggling to keep alive'; re-tooling 'merely prolonged the death throes'. So closures and amalgamations came thick and fast. Quarries were filled in at Woodside and Hilton, and industrial waste was dumped at Persley and Blackburn. Kemnay continued, and continues, to produce roadstone and its own synthetic stone from crushed granite, as well as some building and monumental stone. Kemnay settmakers had long gone, the workforce reduced to just two old men by the 1950s. In 1970 the 480-foot-deep hole at Rubislaw, said by its owner Aberdeen Construction Group to be an 'asset ... we want to get value out of it', was no longer required and no good stone had been taken from it since 1968. At the end only twenty-six men were employed on site. Abandoned, the quarry gradually filled with water, and thirteen years later the Aberdeen Granite Association was wound up. With closures and amalgamations, the monumental industry had been reduced to two major city centre firms and a smaller one at Persley. The 'romance' of the industry, as William Diack described it, was past.

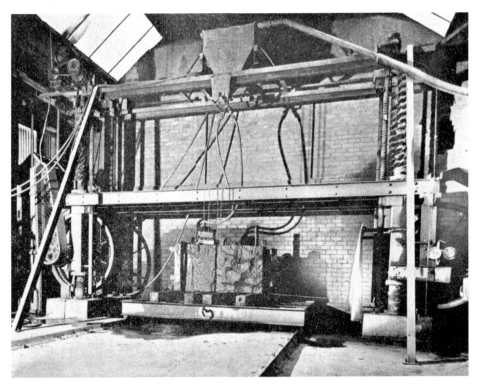

George Cassie & Sons' twin-wire saw.

(3)
HYDRAULICALLY OPERATED TURNTABLE.

This is of a Heavy Duty construction with a 4" dia. Hydraulic Ram capable of lifting 20 tons and with Rails attached to the Top Plate easily raises the Saw Car and Stone and is rotated to the desired position and lowered by a release valve on the small Hand Pump. 3 Bogies serve the 2-Saws through this Turntable.

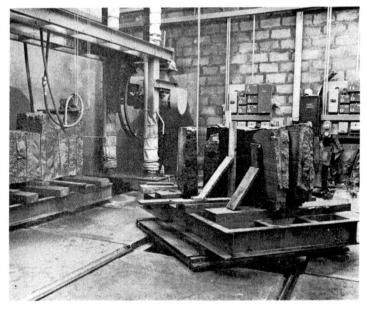

George Cassie & Sons mechanising granite production, 1960s.

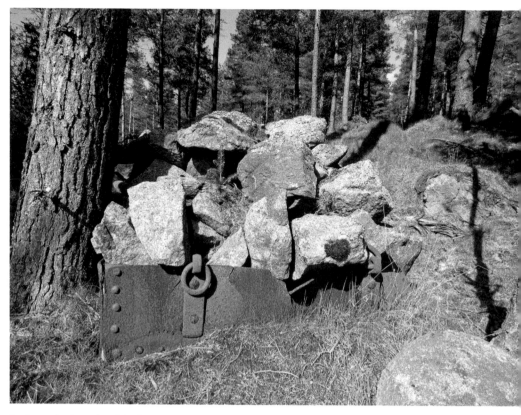

Perhaps the last skip lifted, and abandoned, at Tillyfourie Quarry.

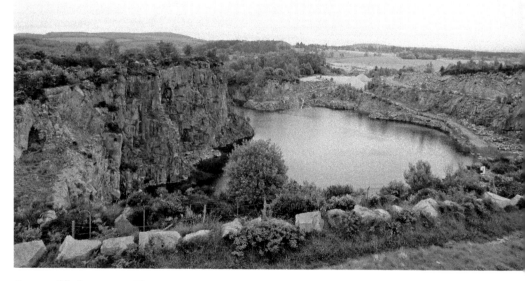

A water-filled quarry at Kemnay.

A water-filled Rubislaw Quarry.

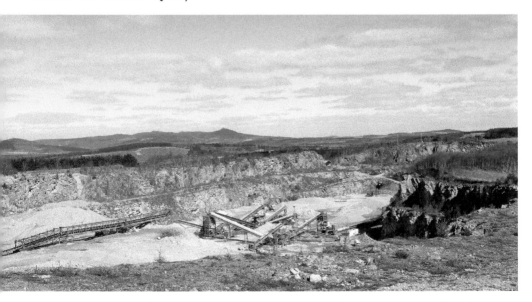

Looking across Craigenlow Quarry to Bennachie beyond, the hill itself a source of building stone.

Reading List

Brogden W. A., *A City's Architecture: Aberdeen as 'Designed City'* (Farnham, 2012).

Diack W., *Rise and Progress of the Granite Industry of Aberdeen* (1950).

Donnelly T., *The Aberdeen Granite Industry* (Aberdeen, 1994).

McLaren J., *Sixty Years in an Aberdeen Granite Yard* (Aberdeen, 1987).

Miller D., *Archibald Simpson, Architect* (Aberdeen, 2006).

Miller D., *Tudor Johnny: City Architect of Aberdeen* (Aberdeen, 2007).